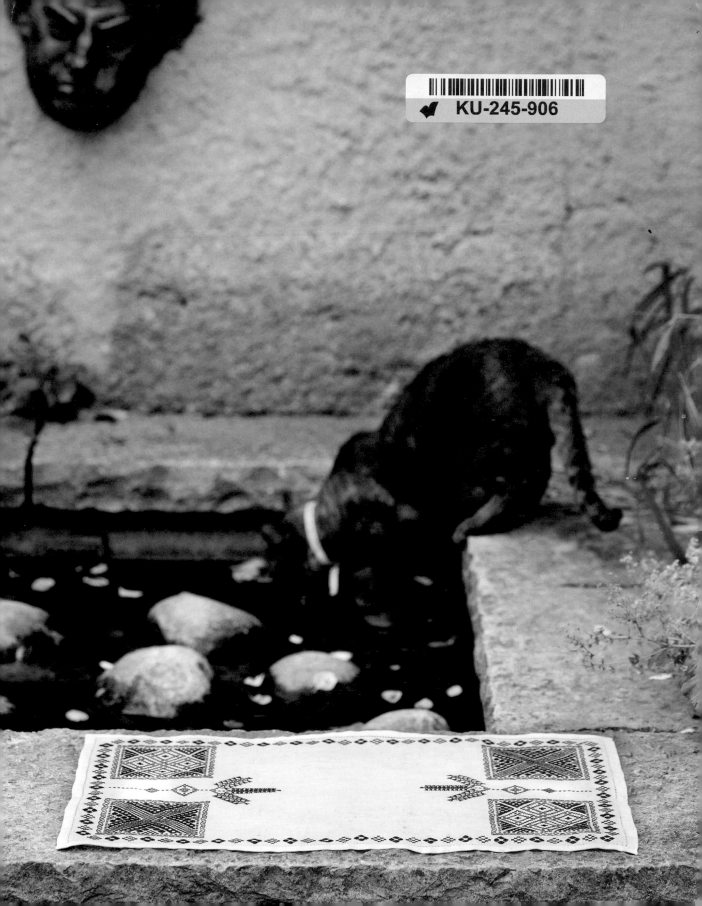

This English edition first published
in Great Britain 2013
Bloomsbury Publishing Plc
50 Bedford Square
London WC1B 3DP
www.bloomsbury.com

ISBN: 978-1-4081-9194-1

A CIP catalogue record for this book is available from the British
Library

Editor: Eva Kruk
Photography: Karin Björkquist
Design: Victoria Bergmark
Reproduction: Turbin, Västerås

Translation from Swedish: Carina Sjöberg-Hawke
Editor: Agnes Upshall
English text layout: Susan McIntyre

This book is produced using paper that is made from wood grown in
managed, sustainable forests. It is natural, renewable and recyclable.
The logging and manufacturing processes conform to the
environmental regulations of the country of origin.

Printed in China

KARIN HOLMBERG

Stitched in Scandinavia

39 contemporary embroidery projects

BLOOMSBURY
LONDON • NEW DELHI • NEW YORK • SYDNEY

CONTENTS

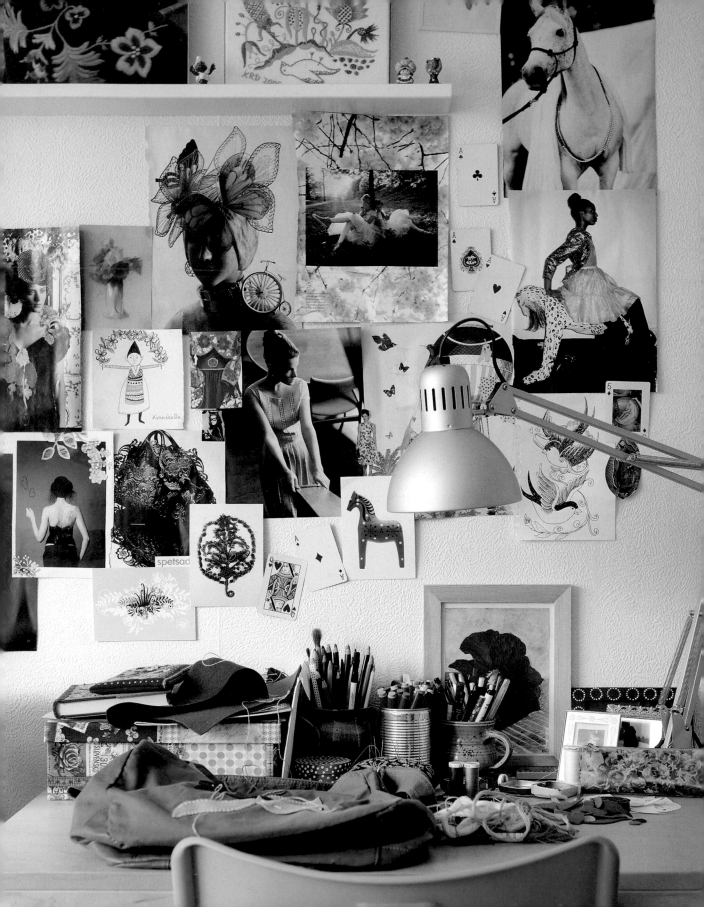

FOREWORD

Traditional textiles, clothes and the rich tradition of embroidery that exists in my country, Sweden, have long been the main sources of my inspiration. The unique way in which strong colours and imaginative patterns were combined in the past is fascinating and sometimes a little surprising. Not everything was grey, homespun fabric. Instead, time and energy were spent on decorating everyday objects – this really tells us something about the need we humans have to be creative, don't you think?

Embroidery is a way of giving home fabrics and clothes a more personal touch. It's also a very accessible craft. You only need a needle and some thread to get started. From there, you can sew onto almost anything. Embroidery is also easy to take with you wherever you go: you can sew on the train, at the cafe or in the company of friends.

This book is primarily intended as a source of inspiration. However, if you would like to stitch the designs exactly as they appear here, you will find all of the patterns at the back of the book. I have provided a selection of eight classic Swedish regional embroidery styles and demonstrate how they can be recreated traditionally or developed into a fresh, new style. My hope is that you will discover these textile treasures for what they are, as well as being inspired to create your own interpretations of them. So, go on, take out a needle and start embroidering!

Karin

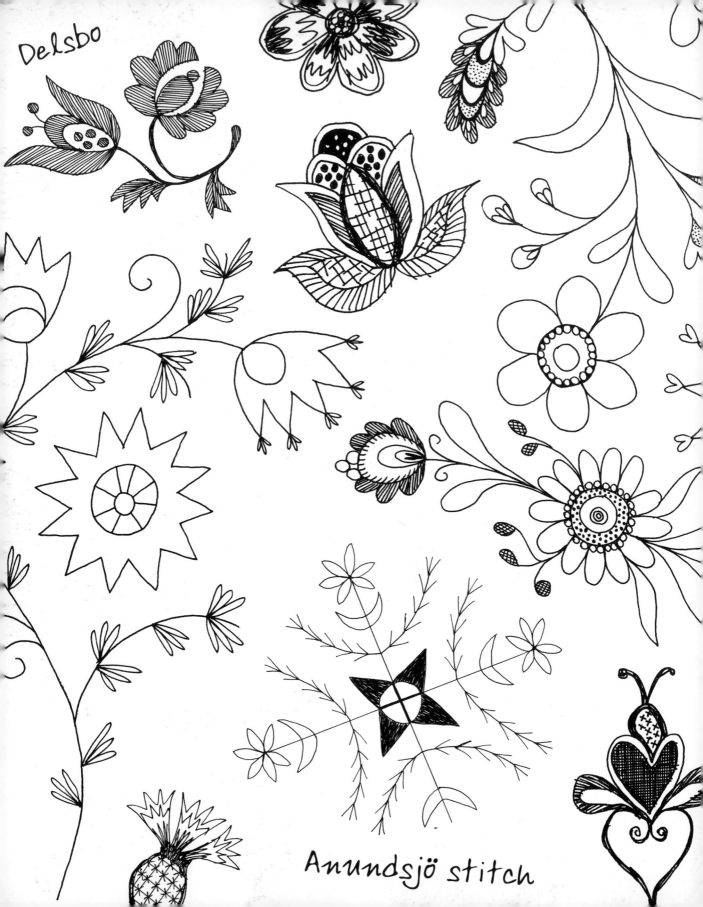

Delsbo

Anundsjö stitch

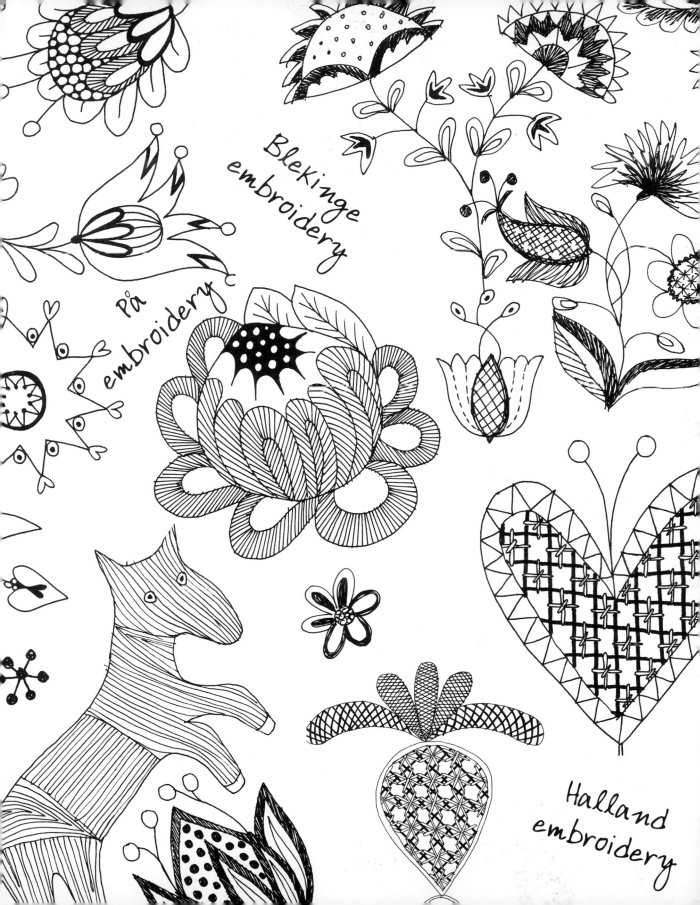

Blekinge embroidery

På embroidery

Halland embroidery

SWEDISH EMBROIDERY STYLES

All the embroidery styles used in this book have their roots in traditional Swedish textiles. More often than not, there is no way of knowing when a special technique was first used, nor who sewed it first, but, probably, in the beginning, they tried to imitate exclusively woven damask fabrics. Later, designs and templates were borrowed and exchanged between farms. Over time, a number of embroideries became extremely popular and many became typically characteristic of different areas of Sweden.

Järvsö embroidery was a method used by rural women to show off their stitching ability as well as the financial status of their farm. In order to show off these skills, every farm had one or more beds with richly decorated bedding, which would be made up purely for decorative purposes. Bedspreads and pillowcases were embroidered using bought red-dyed cotton thread. Some of the threads were not genuine 'Turkish red' and, over the years, have become faded so that now they look more like pink. The motifs are usually different types of flowers, in a more or less conventional style. The techniques used are surface satin stitch and stem stitch. What distinguishes Järvsö embroidery from other styles is its characteristic 'rays' sewn on using four or five stitches. In some books, you might notice that the style is actually called the 'diamond ray stitch'. It's fairly quick and easy to do Järvsö embroidery. A clever idea is to fasten the long stitches in the flowers with small stitches; then the embroidery stays in place better.

Delsbo embroidery is similar to the Järvsö style, but has a different pattern. The motifs are usually flowers and leaves, but they're more circular than the sprawling shapes of Järvsö embroidery, though like Järvsö embroidery, Delsbo embroidery is also sewn with red cotton thread and surface satin stitch. It is customary to fasten the stitches using a wreath of stem stitches around the middle of the flower. The design was often drawn using cut-out templates on paper or birch bark, handed down and shared between many embroiderers. This explains why many embroideries are so alike and commonly found within a certain region.

The *Anundsjö stitch* is the only technique which is associated with a specific person, namely Brita-Kajsa Karlsdotter. She lived in Ångermanland (an historical province in northern Sweden) during the 1800s and started embroidery in her old age, something which is said to explain the slightly shaky and charming style of this particular technique. Rumour has it that she would always ask her children and grandchildren to thread her needles for her when they were visiting, so that she could continue to embroider later on her own. The motifs for this stitch are also red flowers with thin stems and lobed leaves, and get their distinctive appearance from the fact that she fastened the long stitch diagonally with a short one. A recurring theme in her work is the embroidering of her initials, BKD, the year and the letters ÄRTHG, which stand for Äran TillHör Gud (the Honour Belongs to God). It doesn't take long to sew Anundsjö stitch, and you don't need to worry about making stitches of equal length: sprawliness is part of its charm!

Halland embroidery often occurs on cushion covers, or 'pudevar' as they are known locally in Halland, the region after which the style is named. The covers are only embroidered on the short side, since that was the side which would have been visible in the room. This style differs quite a lot from the others. Halland embroidery has a much more conventional and geometric approach. It consists of circles, triangles, stars and hearts, which are often combined with flowers and a tree of life. Also typical of this style is the use of laid filling stitch to fill the shapes. This is sewn by stitching the thread into the shape of a net, either straight or diagonally, which you then fasten with different kinds of stitches. You hide the outlines neatly with chain or stem stitch. Surface satin stitch can appear in this style, but it's more common to cover bigger surfaces with herringbone stitch. In case those stitches also become too long, they can be fastened with chain or stem stitch. Ordinarily, red and blue cotton thread is used. By combining these two colours with different laid filling stitches it is possible to get almost unending variation in your embroidery. Halland embroidery requires quite a lot of accuracy, but you'll soon get into it, and it can be rather relaxing just sitting back and filling in circles with different stitches.

Blekinge embroidery features many elements from other regional styles. It combines surface satin stitch, long and short stitch (often with two shades of thread twisted together for extra nuance), laid filling stitch, stem stitch and French knots. The motifs are flowers, floral baskets, birds, people and so forth. It is sewn using cotton thread in different shades of blue and pink. This kind of embroidery was often sewn on wall hangings or put up for social occasions in the home, and might depict scenes from the Bible. If you're not religious, Blekinge embroidery will give you the opportunity to develop your romantic side and go crazy with pink flowers galore!

På embroidery is satin stitch sewn using woollen thread (often called Zephyr wool: quite a soft, fluffy wool in bold, bright colours), and in principle is only found on traditional clothes from Floda in Dalarna, a region of northern Sweden. For this reason, it's sometimes called Dala-Floda embroidery. The designs consist of an abundance of flowers and leaves, from lifelike violets to fantastic roses. Some embroiderers in Floda evidently embroidered very freely, taking inspiration from nature around them, but many made things easier for themselves by using templates. The biggest flowers were the first details to be embroidered, and they were placed on traditional bonnets, jackets and skirt hems; the remaining space was then filled with leaves and smaller flowers. The name comes from people saying that a person *söm på*, meaning 'stitched on' something (*på* means 'on' in Swedish). Several embroiderers in Floda were so skilled that they could make a living by doing embroidery and selling their products. I try not to favour different embroidery styles, but nevertheless, this is probably the stitch I think is the most fun and gives the nicest looking result. Unfortunately, the thick wool used for this technique makes it only really suitable for clothes and the odd cushion.

Scanian woollen embroidery is also sewn using wool on homespun or broadcloth, but differs from På embroidery in many ways. It is often sewn using thread which has been twisted more tightly than usual, giving a slightly rougher appearance. The colour palette is restricted to red, green, dark blue, white and ochre. Religious motifs are common, especially Adam and Eve in the Garden of Eden, with wonderfully naïve characters and many plants and fantasy animals filling the entire space. In the world of traditional art, a fear of empty

space is often discussed, and Scanian embroidery is a good example of this. It was especially common for an embroiderer to decorate pillows and cushions. The embroidery uses both motifs and colours similar to tapestry weavings; most likely embroiderers used threads left over from weaving. Some of these embroideries were put together using only geometric shapes such as stars and diamonds, and consequently look even more like weavings. The stitches used are satin stitch, stem stitch, chain stitch (which is often used to fill bigger areas) and long-armed cross stitch. If, like me, you love flower patterns with a lot of detail, then you'll find this style a lot of fun! And since chain stitch fills spaces quickly, it doesn't take as long as you might think.

Blackwork has its roots in court dresses from the continent, where it was also known as *Spanish stitch* or *Holbein stitch* (after the artist Hans Holbein the younger, who skilfully depicted it in royal portraits). In Sweden, it's mostly found on traditional scarves from Leksand, Åhl and Gagnef in Dalarna. Blackwork is a combination of cross stitch, satin stitch and backstitch sewn using black silk on fine even-weave linen. By counting while you're embroidering, you achieve very exact geometric shapes. In other words, it requires both good eyesight and the patience of an angel; but such meticulous tasks can, I think, be fun to do for a change from time to time. You can also experiment more freely if you want to, and create modern, illustrative embroidery with this stitch.

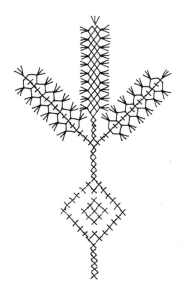

Projects

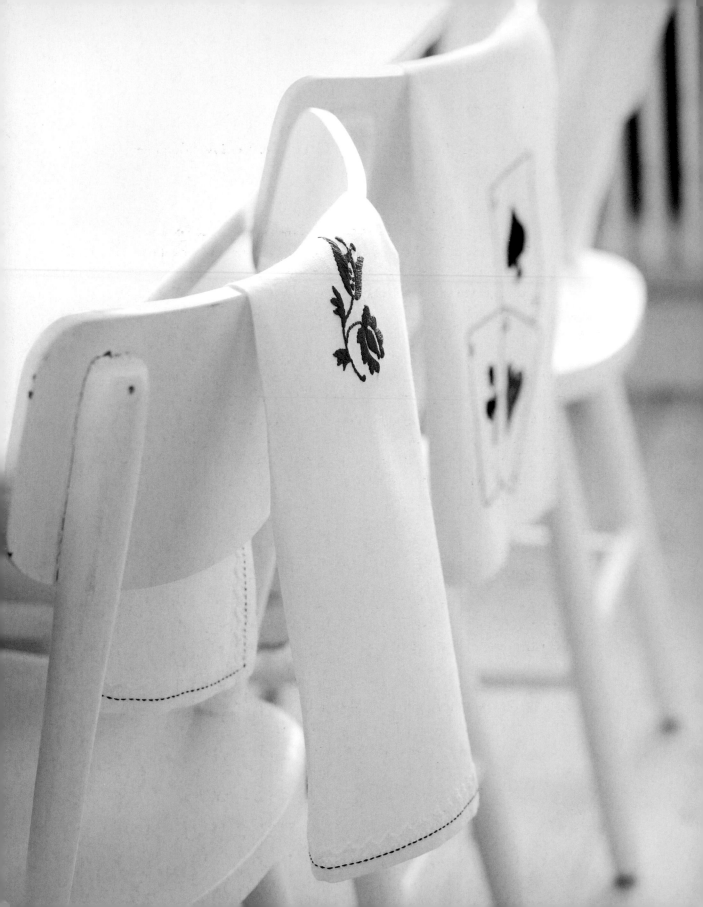

DELSBO FLOWER TEA TOWEL

Embroidery motifs don't have to be large. Just a small Delsbo flower decorates this tea towel.

Technique: Delsbo embroidery
Materials: ◉ red mercerised thread or DMC mouliné stranded cotton
 ◉ white linen fabric, approx. 49 x 64 cm, or a ready-made white linen tea towel, approx. 45 x 60 cm
 ◉ cotton ribbon for hanging
 ◉ any lace ribbon
Design: See page 95.

Instructions: fold in all the edges and hem the fabric by hand or machine (or use a ready-made tea towel). If you wish, sew a lace ribbon around the edge of the towel. Sew on a cotton ribbon loop for hanging.

Mark the middle of the tea towel. Transfer the design centred on this point and embroider it in surface satin stitch and stem stitch. Use one strand of mercerised cotton or three strands of stranded cotton. Fasten off all threads and iron the tea towel.

PLAYING CARD TEA TOWEL

The geometric designs of Halland embroidery inspired me to make a tea towel with a playing card motif. Use it when you're baking and play patience while the dough is rising!

Technique: Halland embroidery
Materials: ◉ red and black linen thread 16/2
 ◉ white sheeting, approx. 49 x 64 cm, or a ready-made white cotton tea towel, approx. 45 x 60 cm
 ◉ cotton ribbon for hanging
Design: See page 94.

Instructions: fold in all the edges and hem the fabric by hand or machine (or use a ready-made tea towel).

Transfer the design and embroider it in Halland embroidery. There should be a variety of laid filling stitches in the playing card and backstitch along the outlines.

WHITE VINE TEA TOWEL

The fact that Järvsö embroidery is usually sewn with red thread on white fabric doesn't mean it always has to look that way. You can achieve exciting effects just by changing the colours around! In addition, this tea towel is sewn using a cotton thread that's not normally used for embroidery, which gives it a bit more of a sprawling appearance than usual.

Technique:	Järvsö embroidery
Materials:	◉ white cotton thread 8/2
	◉ red sheeting, approx. 49 x 64 cm, or a ready-made red cotton tea towel, approx. 45 x 60 cm
Design:	See page 95.

Instructions: fold in all the edges and hem the fabric by hand or machine (or use a ready-made tea towel). Draw a wavy line on the tea towel. Transfer the Järvsö flowers from the design page and place them where you think they look best. Draw small stems here and there. Embroider using surface satin stitch and fill out with diamond ray stitches, creating leaves on the stems.

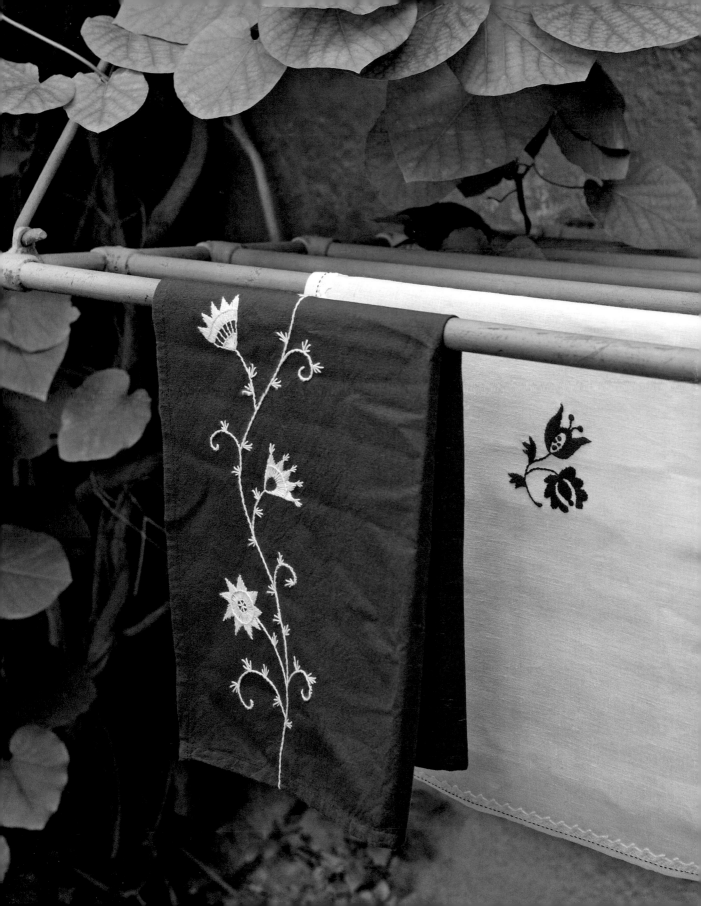

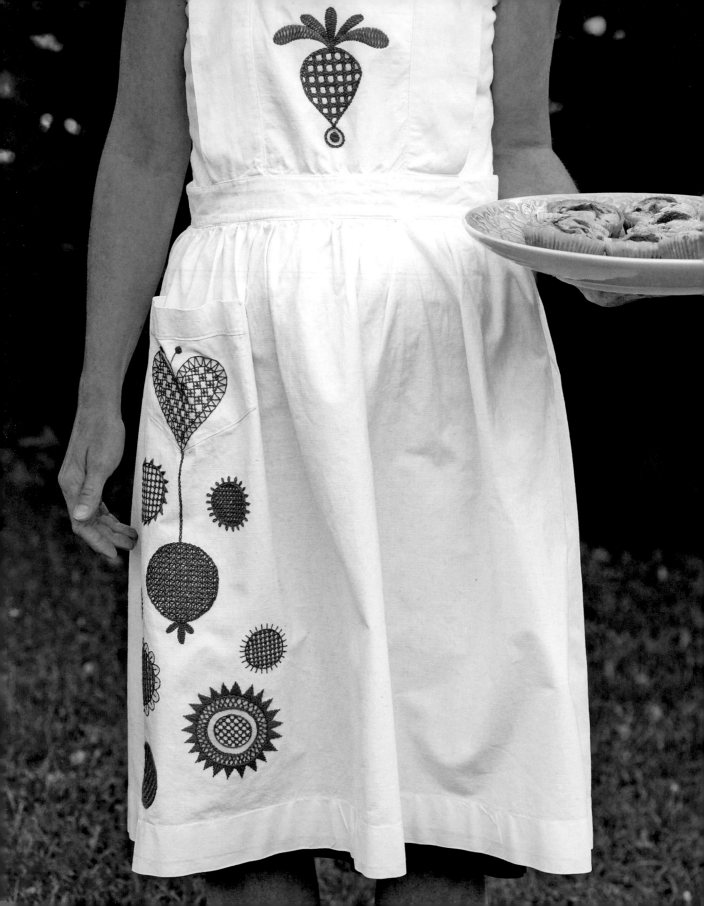

KITCHEN GARDEN APRON

If you are lucky enough to find a pretty apron at a flea market or in your grandmother's attic, and it's completely undecorated, just go crazy with a needle and thread and make it your own. The circles are drawn using glasses, cups, candles … anything round, depending on the size you want for the finished embroidery.

Technique:	Halland embroidery
Materials:	◎ a white cotton apron
	◎ red and blue DMC embroidery thread
Design:	See page 96.

Instructions: draw circles, hearts and similar shapes of your choice on the apron, using a pencil or water-soluble pen. Attach an embroidery hoop and ensure the fabric is stretched taut and even. Sew laid filling stitches in one or two colours using two threads. Try to vary the stitch types and edge seams on the apron. Do as much or as little stitching as you see fit.

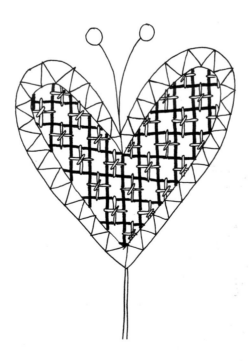

ROSE AND TULIP POTHOLDERS

Some may think that making your own potholders is a bit too much, but it's great fun! The embroidery fulfils the same purpose here as when you make a patchwork quilt and the result is a smooth, heatproof potholder.

Technique: Running stitch, inspired by the designs of Delsbo and Järvsö embroideries

Materials: ◉ cotton fabric, two pieces 18 x 18 cm (preferably use patterned fabric on the back, as the embroidery won't look so neat there)
◉ wadding, 16 x 16 cm
◉ ribbon for hanging
◉ DMC mouliné stranded cotton in colours matching the fabric

Design: See page 97.

Instructions: transfer the design you want to embroider onto the piece of plain fabric. Fold the fabric around the wadding with a 1 cm seam allowance. Take the patterned fabric and fold in a 1 cm seam allowance; place it on the back of the potholder. Cut a piece of ribbon, long enough for hanging. Place it in one corner, between the fabric and the wadding, and tightly pin around the whole potholder. Ensure that the corners are neat. Sew together using tight running stitch or a machine.

When the potholder has been sewn together, it's time to embroider it. Pin all three layers together in a few places so that the wadding doesn't pull while sewing. Sew running stitch using two threads of stranded cotton through all three layers, along the lines of the design. Don't pull too tightly, or the fabric will pucker and become misshapen. Fasten off the thread at the back by making a couple of small stitches; just pass the needle down in the top fabric and up again a bit further away. Cut the thread close to the fabric.

Note: if you want to add lace along the edge, as on the red potholder, it is a good idea to sew it on one piece of fabric first, before sewing all the layers together. Otherwise there will be far too many pins.

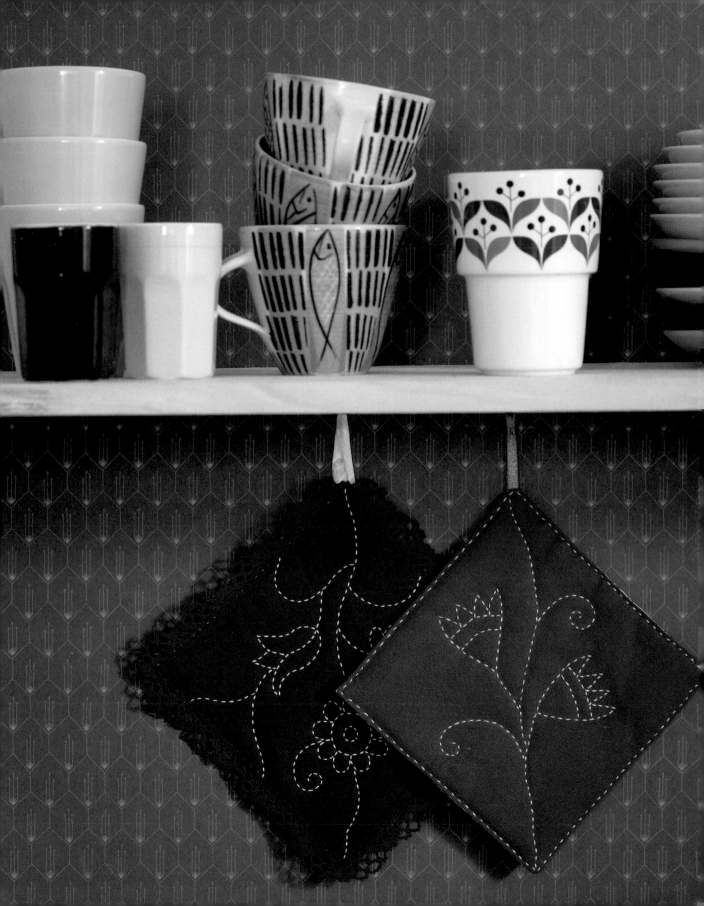

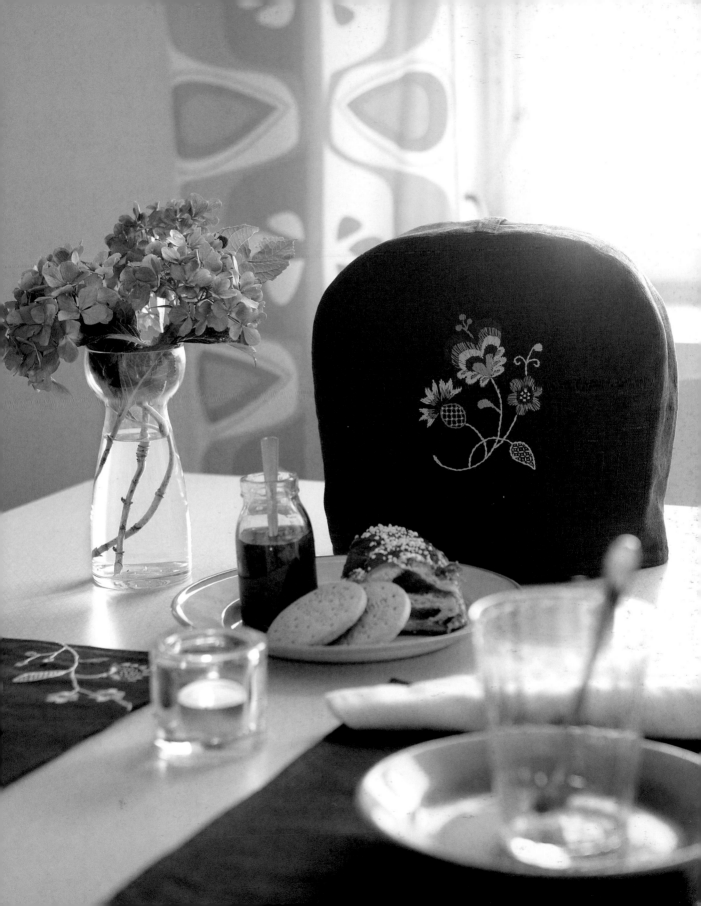

BLEKINGE FLORAL TEA COSY

If you like your tea brewed in a teapot and kept warm during your entire Sunday breakfast, making a tea cosy is a great sewing and embroidery project. You can either embroider a small motif or decorate the whole cosy.

Technique:	Blekinge embroidery
Materials:	◉ linen, two pieces 26 x 26 cm plus one piece 8 x 70 cm
	◉ cotton lining, two pieces 26 x 26 cm plus one piece 8 x 70 cm
	◉ wadding, two pieces 26 x 26 cm plus one piece 8 x 70 cm
	◉ bias tape, approx. 75 cm
	◉ pink, blue, yellow and white DMC mouliné stranded cotton
Design:	See page 98.

Instructions: for the outer shell, lining and wadding, there should be two side panels and a centre strip. On the side panels, cut curves on two adjacent corners. Work zigzag stitch on a sewing machine around the entire edge of the outer shell and lining.

Transfer your chosen design onto the outer shell, in the middle of one of the side pieces. Work Blekinge embroidery with two threads of stranded cotton, using an embroidery frame to prevent the fabric puckering. When you've finished embroidering, press the fabric on the reverse using a hot iron.

Sew the tea cosy together as follows: start by sewing the outer shell and the handle. Cut 8 cm of bias tape, fold it lengthways and sew two straight stitches approx. 1 mm from the edge. Place the tape crosswise in the middle of the right side of the centre strip and pin. Pin the centre strip to one of the side panels, right sides together, and sew the pieces together with a straight stitch 1 cm from the edge. Pin the other side of the strip to the other side panel and sew together in the same way. Press the seams with a hot iron.

Turn the cosy inside out so that the right side now emerges, and sew a strengthening straight stitch 1 mm on each side of each seam. The outer shell is now finished; the bias tape works as the tea cosy's handle.

Sew the lining: place the wadding on top of the lining and baste them together using lengthways straight stitches. Sew the lining pieces together in the same way as the outer part. Trim any excess wadding and loose threads.

Stuff the lining inside the outer shell. Your tea cosy is almost finished.

Pin together the lining and outer shell at the base and sew using straight stitch approx. ½ cm from the edge. Trim the seam with scissors.

Fold the remaining pieces of bias tape over the bottom edge and sew on using straight stitch, as close to the edge of the tape as possible. Make sure your stitches fasten the tape on both the inside and outside of the tea cosy.

BLEKINGE FLORAL PLACE MATS

Complement your tea cosy with matching placemats. Consider the position of the embroidery design so that it goes well with your crockery and cutlery.

Technique: Blekinge embroidery
Materials: ◉ linen fabric, two pieces 35 x 48 cm
◉ pink, blue, yellow and white DMC mouliné stranded cotton
Design: See page 98.

Instructions: zigzag stitch around the edges of the fabric. Transfer the design using a water-soluble pen or a pencil. It's best to draw the stems all the way to the edge, despite the fact that you'll fold in a seam allowance later. Work Blekinge embroidery with two threads of stranded cotton, using an embroidery frame for the best results.

Fold in all the hems by 1 cm, then a further 1 cm so that the zigzag stitch can't be seen. The mat should now measure 31 x 44 cm. Pin and sew by hand or using straight stitch on a machine. Press the finished mat with a hot iron.

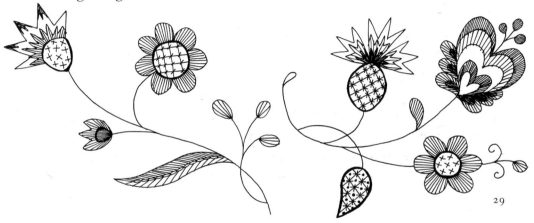

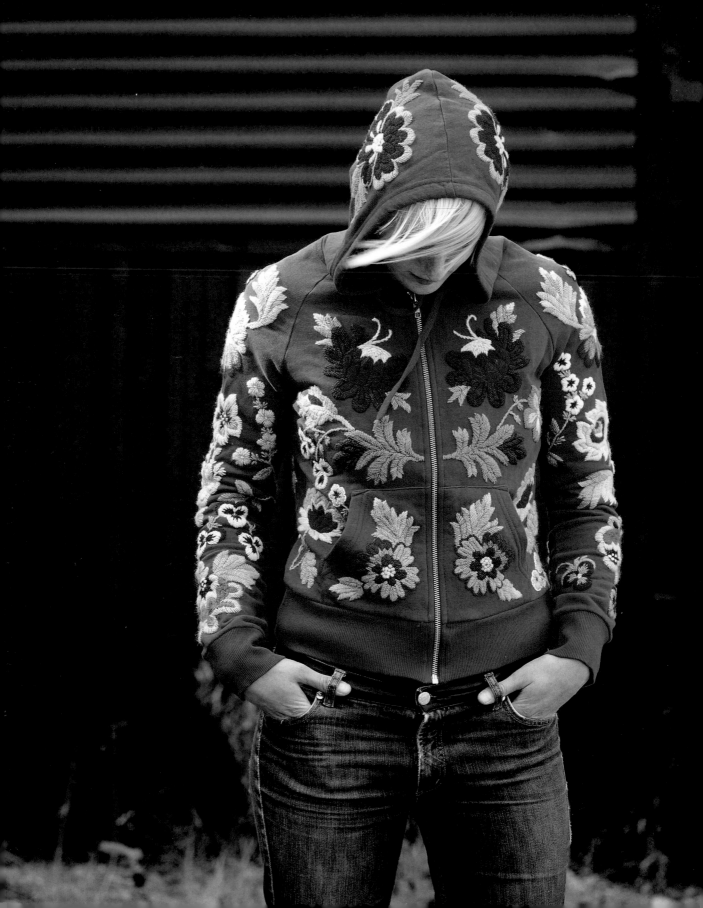

WOMAN'S HOODIE *FROM DALARNA*

The traditional flowery jackets from Floda in Dalarna are inspiring with their extravagant embroidery. Nowadays, though, not many people wear traditional clothes; instead they wear comfortable clothes made of jersey fabric. So why not combine the two?

This is quite a big project and will take a bit of time. It also requires patience and practice to be able to embroider onto the sleeves, because you won't be sewing on even fabric.

Technique: På embroidery
Materials: ◉ wool yarn, in different colours
 ◉ one plain cotton hooded jersey
Design: See pages 99–100.

Instructions: transfer the design to cardboard or thick paper and cut out the templates. Place them on the jersey where you think they will work best. It's easier to do this when someone is wearing the garment, so you can see clearly how the design forms around the body. Draw around the templates with a water-soluble pen. Start with the biggest flowers, and fill in with smaller ones plus leaves and stems. Work På embroidery, using an embroidery hoop where possible. Be careful not to pull the stitches too tight, especially on the sleeves.

Wash the finished hoodie, either by hand or on a wool setting in a washing machine, and dry flat.

MAN'S HOODIE *FROM DALARNA*

If you don't have the time or patience to embroider the whole hoodie, just sewing on a few individual flowers still gives a rather nice effect. The back, the front and the hood are easiest to get at and, with these, it's also best to use an embroidery frame.

Technique: På embroidery
Materials: ◉ wool yarn, in different colours
 ◉ one plain cotton hooded jersey
Design: See pages 99–100.

Instructions: follow the instructions for the woman's hoodie. If the design is placed on the back, it's easy to transfer it if the garment has been laid out flat. However, it might be wise to try it on someone first before starting the embroidery, to ensure that the design definitely ends up where you planned.

PARADISE LEGGINGS

Make your favourite pair of leggings a little more personal with winding flower vines in Järvsö embroidery. Here, they've been sewn using lovely pink silk, but stranded cotton is just as good.

Technique: Järvsö embroidery
Materials: ◉ silk thread or DMC mouliné stranded cotton in one or
 more shades of pink or red
 ◉ a pair of leggings
Design: See page 101.

Instructions: transfer the design to the leggings using a water-soluble pen. Work Järvsö embroidery using two strands of thread. Use a smaller embroidery frame for the flowers. The stems can be sewn without a frame, but ensure not to pull the stitches too tight – the leggings have to stay stretchy.

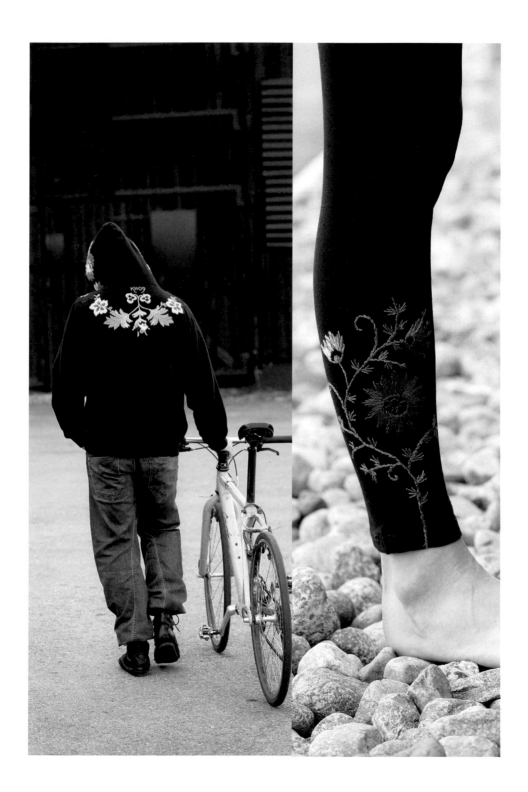

OTHER SIDE OF LEKSAND T-SHIRT

Blackwork is traditionally sewn on the scarf that is worn with the traditional costume of Leksand, an exquisite and detailed piece of craftsmanship. Here, it's been interpreted freely and placed on the side of a T-shirt, but the stitches and colours are the same.

Technique: Freestyle blackwork
Materials: ◉ black DMC mouliné stranded cotton
 ◉ one suitably-sized T-shirt
 ◉ even-weave linen or Aida cloth
Design: See page 102.

Instructions: mark up the area of the T-shirt you want the embroidery to cover. It's best if you tack a thread along the lines so that you can pull it away and avoid leaving pen marks. Try the shirt on someone else to see how the design will look on the body. Then cut out a piece of even-weave linen or Aida cloth, the same size as the design. Sew overcast stitch around the edge so that it doesn't fray. Firmly tack the supporting fabric inside the marked area. Embroider blackwork with two or three threads of stranded cotton, through both the cloth and the T-shirt. Either sketch your shapes on the cloth, then fill them in, or sew completely freely. Keep in mind that nice shapes will form from the gaps between the patterns you embroider. Ensure that the needle comes up precisely between the threads in the supporting cloth, otherwise it will be difficult to remove. When you've finished sewing, remove the supporting cloth: cut into the cloth with embroidery scissors and around the finished embroidery, in order to remove the hemmed edge. Carefully pull out the loosened threads, one at a time, first the horizontal and then the vertical. The embroidery is now left on the T-shirt, flat and even.

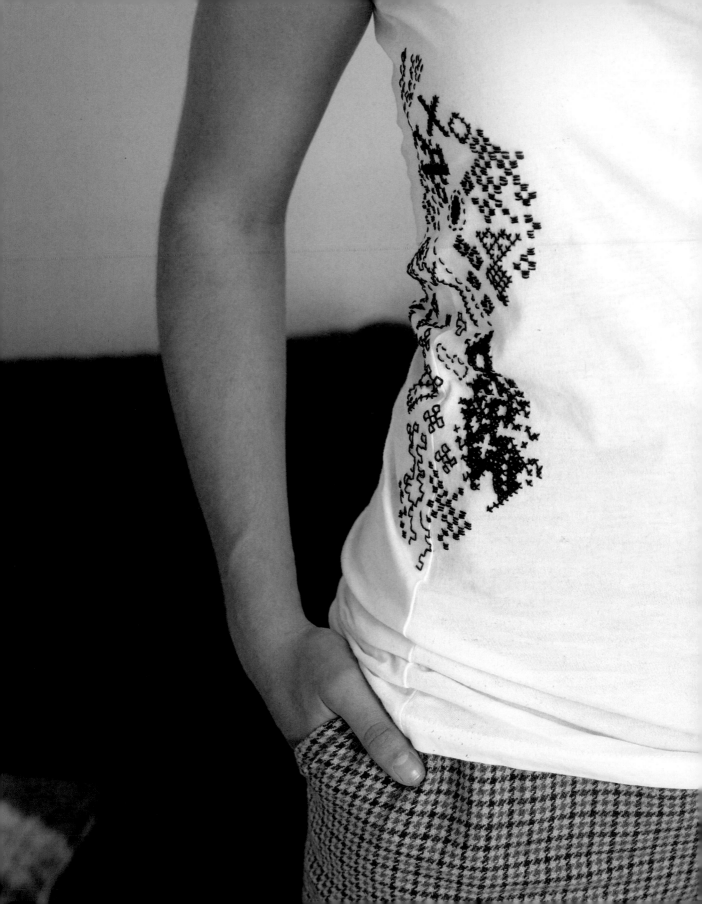

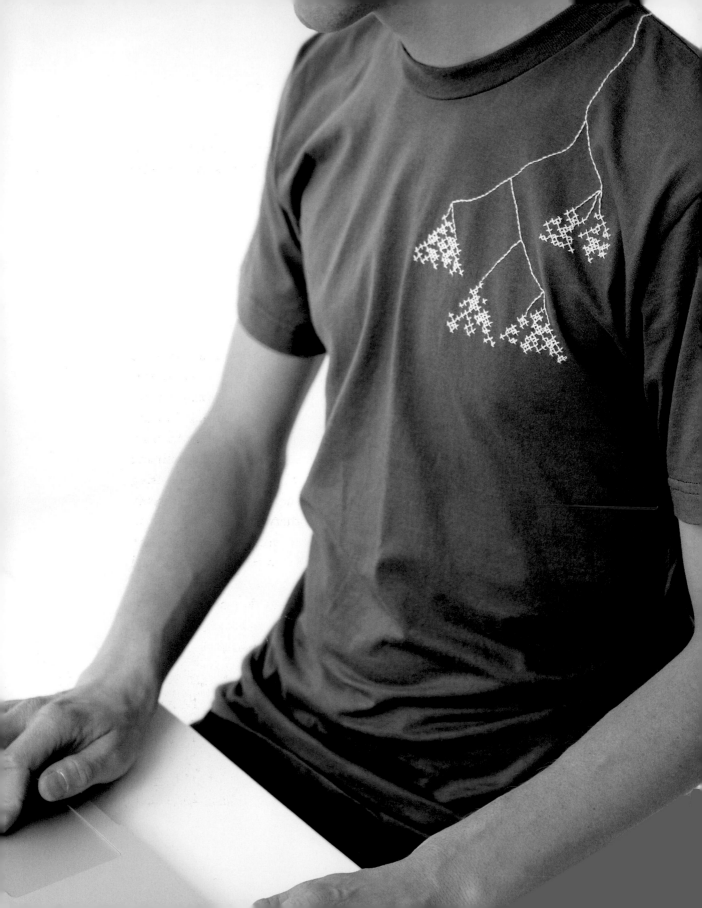

WAX PLANT T-SHIRT

This is the freest interpretation of all the traditional regional stitches in this book. The question is whether it can really be called blackwork, since it's actually sewn in white thread.

Technique:	Freestyle blackwork
Materials:	◉ white DMC mouliné stranded cotton
	◉ one suitably-sized T-shirt
	◉ even-weave linen or Aida cloth
Design:	See page 103.

Instructions: transfer the design using a white marker pen, but don't press too hard – the design can easily come through. Cut out pieces of even-weave linen or Aida cloth to cover the design area, in this case approx. 5 x 5 cm. Oversew stitches around all the edges to prevent the cloth fraying. Pin and tack the cloth firmly over the design so that it is covered exactly. Start stitching your design onto the cloth. Embroider through both the cloth and the T-shirt with two threads of stranded cotton. Fill the drawn shape using cross stitch and/or satin stitch. Ensure that the needle comes up precisely between the threads in the supporting cloth, otherwise it will be hard to remove. When the embroidery is complete, cut into the cloth with embroidery scissors, around the finished embroidery, in order to remove the hemmed edges. Carefully pull the loosened threads, one at a time, first the horizontals and then the verticals. The embroidery itself is now left on the T-shirt, straight and even. Repeat with the other design shapes. The stem that links the flowers is sewn using backstitch and doesn't need any supporting cloth.

Note: if you're not overly finicky, you can embroider cross stitch, satin stitch and backstitch without using any supporting fabric, giving your shirt a bit more of a personal touch.

BOUQUET T-SHIRT

Blekinge embroidery is well suited to children's clothes, with its pastel colours and cute motifs. This design in particular, with its little basket of flowers, is done using laid filling stitch, and is often seen on old tapestries and cushions.

Technique:	Blekinge embroidery
Materials:	◉ cotton thread, e.g. DMC embroidery thread or blue, pink, yellow and turquoise DMC mouliné stranded cotton
	◉ one suitably-sized white T-shirt
Design:	See page 104.

Instructions: transfer the design to the middle of the T-shirt. Attach a frame and stitch Blekinge embroidery using two threads. Try mixing two different coloured threads for greater variation. Press the T-shirt lightly in order to remove the mark made by the frame.

LITTLE POSY TROUSERS

These child's trousers are embroidered using the softest tapestry wool you can find, so as not to be itchy on the skin. The pattern is placed low down on the leg, where it's relatively easy to get at for sewing and where it won't wear too quickly either.

Technique:	På embroidery
Materials:	◉ DMC tapestry wool in different colours
	◉ a pair of child's trousers in black
Design:	See page 104.

Instructions: transfer the design using a white marker pen. Use a frame, if there's room, otherwise try to hold the fabric as even as possible with one hand. Be careful not to pull the stitches too tight. You can divide the thread into two if you wish; experiment to see how thick you want the embroidery to be.

LITTLE HEART T-SHIRT

Halland embroidery is usually worked with red and blue thread on white fabric, but here I have swapped things around a little. In other words, you're free to spill some ketchup without it making any difference!

Technique:	Halland embroidery
Materials:	◉ white and blue DMC mouliné stranded cotton
	◉ a suitably-sized red T-shirt
Design:	See page 105.

Instructions: trace the heart template and place it on the T-shirt. Draw around the template using a water-soluble pen or a pencil. Draw more hearts beside it, but ensure there is enough room to sew around the edges. Attach a small embroidery frame around one heart at a time and embroider laid filling stitch within the shape. Stitch using two strands of thread. Finish with a border of backstitch, chain stitch and/or running stitch. Repeat for the other hearts.

Note: it's easier to embroider on a T-shirt where the ribbing is not particularly noticeable, so try to choose a jersey top whose fabric is as smooth and as even as possible.

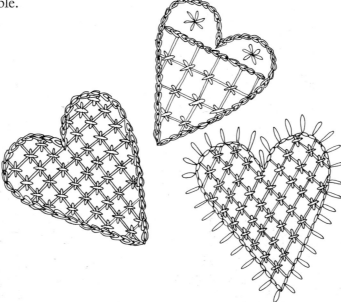

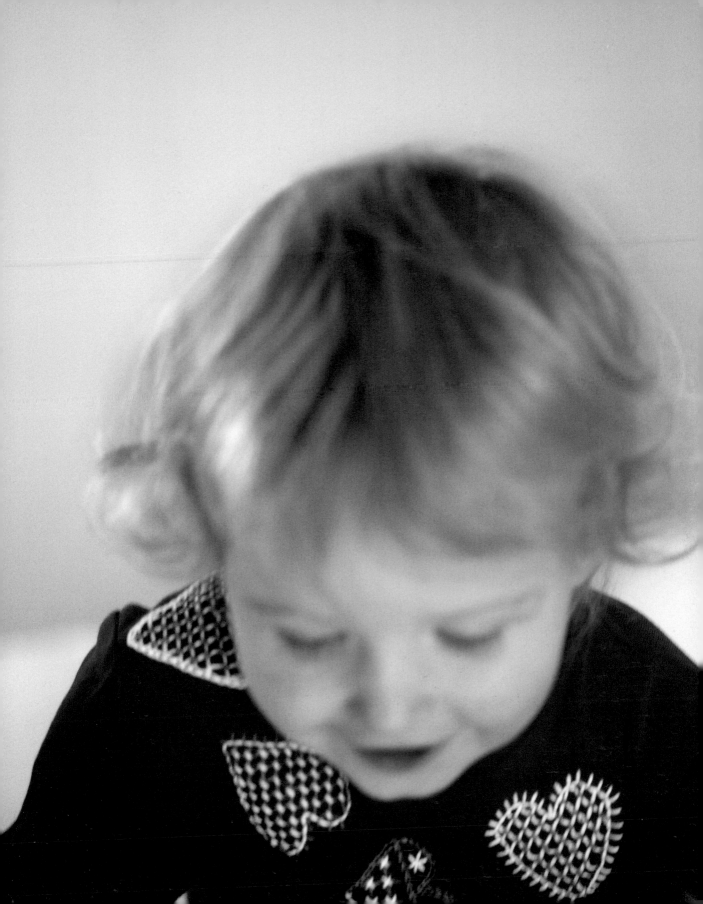

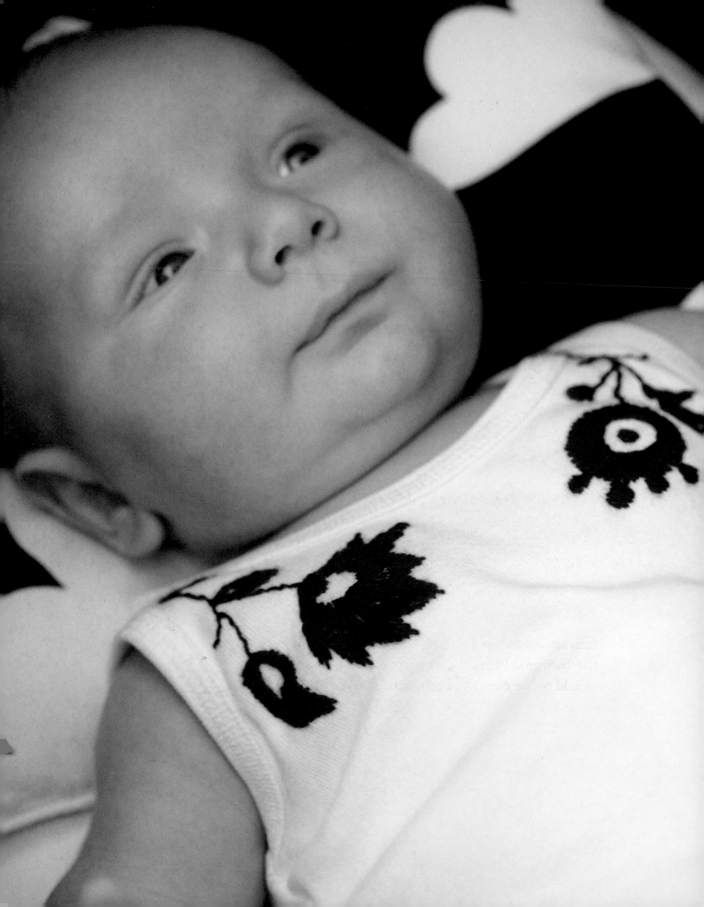

MARIGOLD BABYGRO

Needless to say, a baby will grow out of this garment very quickly, but for a short time it will look marvellous! It will look especially nice with a matching hat.

Technique:	Delsbo embroidery
Materials:	⊚ red cotton thread, e.g. DMC embroidery thread
	⊚ a white babygro
Design:	See page 106.

Instructions: transfer the design with a water-soluble pen, either around the neck or just on the front. Stitch Delsbo embroidery using two strands of cotton thread. Be extra careful and try to keep your stitches even, because it's difficult to make room for a frame on such a small garment. Babygro fabric is often ribbed to make it extra elastic, so make sure you don't pull your stitches too tight.

MARIGOLD BABY HAT

Technique:	Delsbo embroidery
Materials:	⊚ red cotton thread, e.g. DMC embroidery thread
	⊚ a white baby hat
Design:	See page 106.

Instructions: follow the instructions for embroidering the babygro. Place the design where you think it should go: on one side, both, or maybe at the back of the neck?

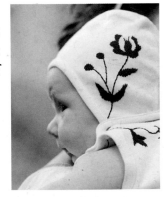

CANDY KNICKERS

Maybe not for everyday use, but there is something wonderful about spending time and energy on decorating plain cotton knickers. Try mixing colours and designs; embroider a big design or just a small monogram.

Technique: Freely-interpreted Delsbo embroidery

Materials: ⊚ DMC embroidery thread or mercerised thread in different colours

 ⊚ cotton knickers in your size

Design: See page 107.

Instructions: follow the instructions for the Delsbo Rose underwear set on the next page, but experiment freely with colours and designs.

44

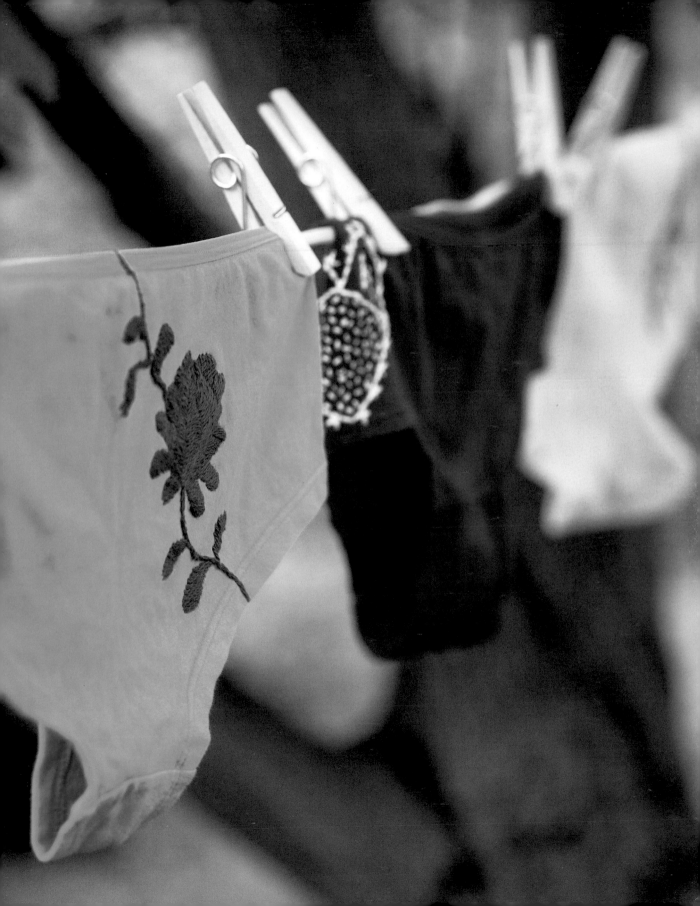

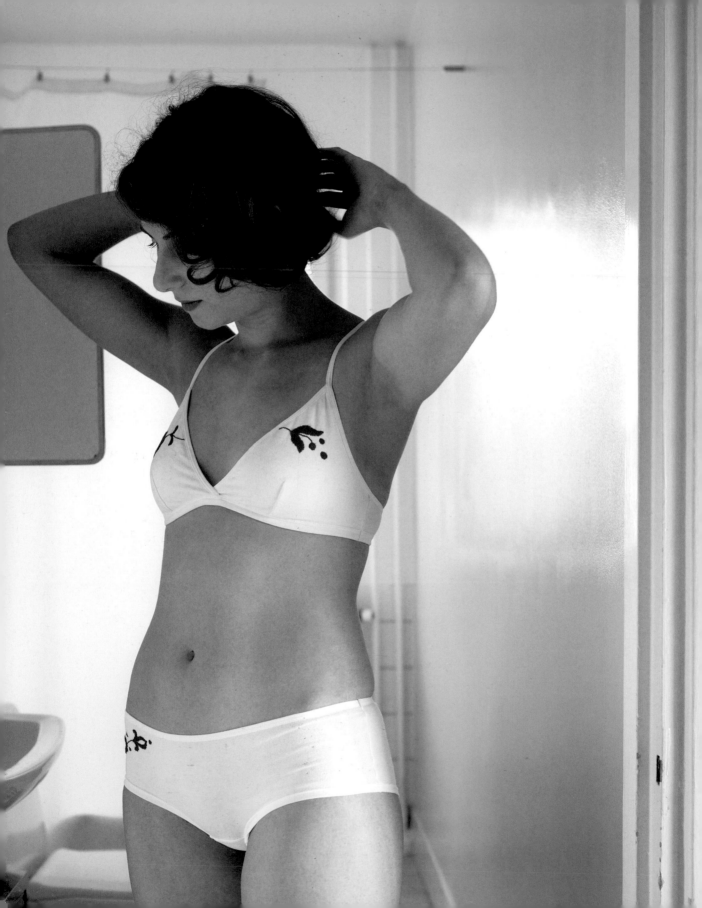

DELSBO ROSE UNDERWEAR SET

Technique: Delsbo embroidery
Materials: ◉ red cotton thread, e.g. DMC embroidery thread
 ◉ a white bra and a pair of white knickers
Design: See page 107.

Instructions: transfer the design to wherever you think it looks best on the underwear. Take into consideration wear and tear, e.g. the stitching will wear more if it's placed in the middle of the bottom. But don't think too hard about it; form is more important than function in this case. Work Delsbo embroidery, using a frame if there's room. Try not to pull the stitches too tight – the garment should still retain its ability to stretch.

MISS HORSETAIL SOCKS

Do you, like me, get confused when doing your laundry and wonder which socks really go together? Why not mark them with matching embroidery!

Technique: Järvsö embroidery
Materials: ◉ one or more pink or red shades of DMC mouliné stranded
 cotton
 ◉ a pair of socks
Design: See page 108.

Instructions: put the socks on. Transfer the design using a white marker pen. Embroider Järvsö embroidery using two strands of cotton, but for best results just stitch the outlines of the flowers. Use backstitch, since it's quite an elastic stitch. Be careful not to pull the stitches too tight: the socks need to stay stretchy! If you think the stitches are getting too loose, sew an extra stitch over them, the same way as you do in Anundsjö stitch (see page 92). Fasten off all your threads and do the same on the other sock.

FOLKLORE WRISTWARMERS

You can stitch up these wristwarmers quickly in just a couple of evenings. They are embroidered using backstitch instead of satin stitch, since this works best on stretchy fabric. It gives it a slightly different appearance, though one which still suits the Delsbo designs.

Technique:	A variant of Delsbo embroidery
Materials:	◉ red DMC mouliné stranded cotton or mercerised thread
	◉ jersey fabric, two pieces 17 x 21 cm, or cut off the bottom part of a pair of old leggings
Design:	See page 109.

Instructions: lay the fabric out flat and transfer the design using a white marker pen. Work the design in backstitch with one red mercerised thread or three stranded cotton threads. You can use the same design on both wristwarmers or a different one on each: it's all down to preference and taste.

When the embroidery is finished, fold the wristwarmer in two, right sides together, and sew the edges together using backstitch. If your sewing machine does tricot stitch, or if you have an overlocker, you can of course use this. Lastly, hem the ends.

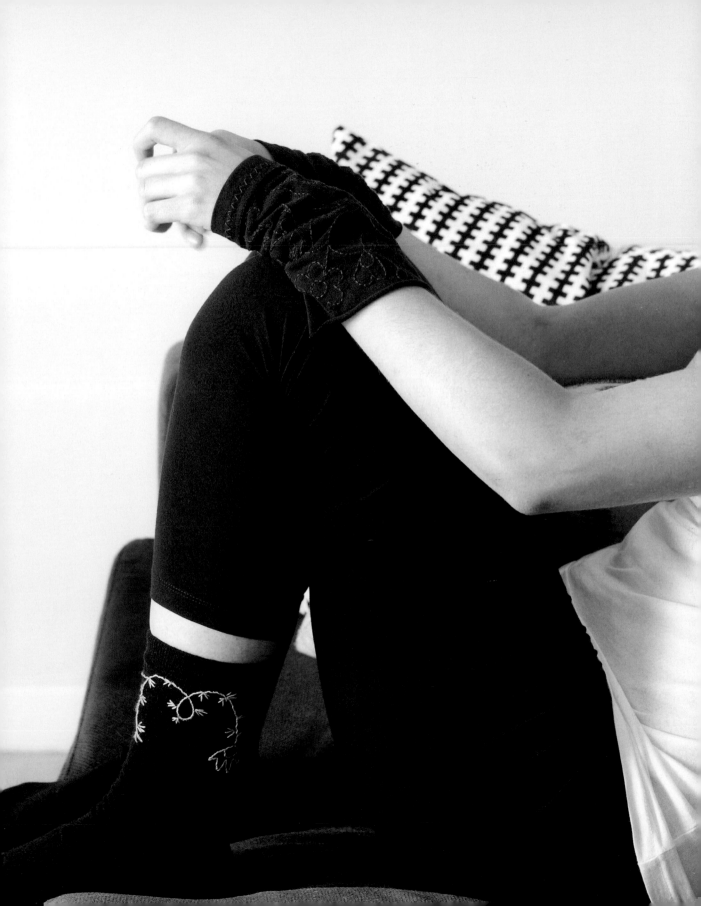

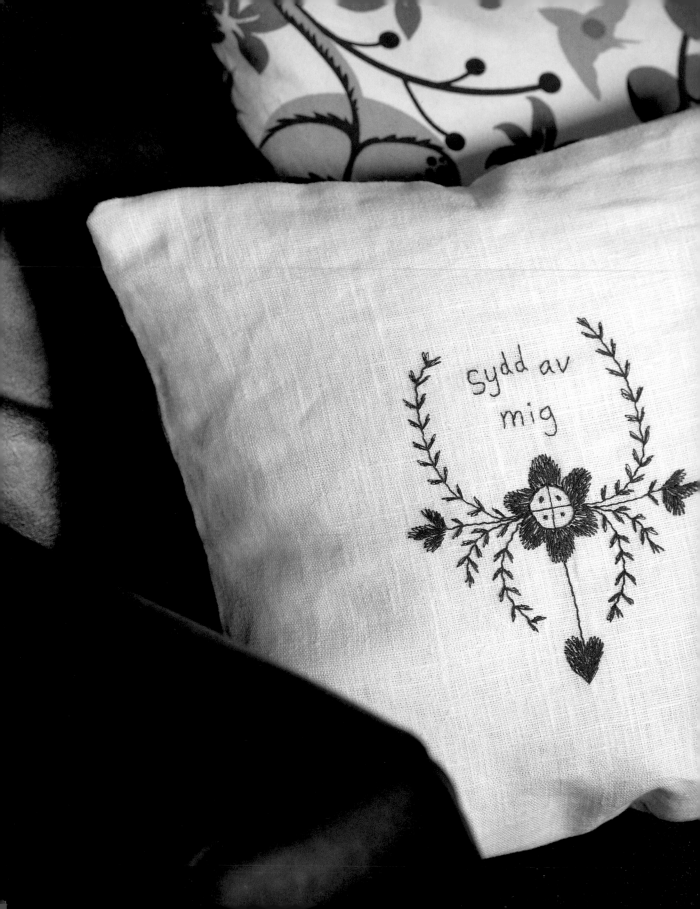

SEWN BY ME CUSHION

Brita-Kajsa, who created the Anundsjö stitch, often included her initials on her designs. So why not personalise your embroidery with your initials, your name or some text. This cushion looks best if the cover fits tightly over the cushion, so I make the finished cushion cover a few centimetres smaller than the cushion itself.

Technique:	Anundsjö stitch
Materials:	◉ red DMC mouliné stranded cotton
	◉ white linen fabric, three pieces: 40 x 40 cm (for the front), 40 x 31 cm and 40 x 21 cm (for the back)
	◉ a cushion pad, 40 x 40 cm
Design:	See page 110.

Instructions: zigzag stitch along all the edges of the fabric pieces. Hem one of the long sides of each of the two back pieces by folding the edge twice, so that the zigzag stitch is hidden. Pin and sew on the machine. These will be the edges of the back opening.

Transfer the design to the centre of the front piece and embroider Anundsjö stitch with two strands of cotton thread. The text is sewn using backstitch. Use a frame. When you're finished, press the embroidery to make it smooth and even.

Place the front piece so that the right side is facing you. Lay the shorter of the two back pieces on top, right side down and same length sides together. Then place the larger back piece on top so that they overlap. Pin all around and sew together on the machine. Turn the cushion cover right side out and stuff with a cushion pad.

FLOWERY CUSHION

Feel free to sew one of the special regional styles using a different thread from what's traditionally used. This cushion design is based on traditional woollen jackets, but when it's stitched using lustrous stranded cotton, you almost get a feeling of Chinese silk embroidery instead.

Technique: På embroidery
Materials: ⊚ DMC mouliné stranded cotton in different colours
 ⊚ cotton fabric in any colour, two pieces 40 x 42 cm
 ⊚ ribbons for closing
 ⊚ a cushion pad, 40 x 40 cm
Design: See pages 99–100.

Instructions: zigzag stitch around all the edges of the fabric pieces. Hem one long side of each piece by folding it over twice, so that the final measurement of the cushion casing is 40 x 40 cm.

Transfer the design to one of the pieces of fabric. Work På embroidery with two strands of cotton thread. Press the finished embroidery to make it flat.

Place the two pieces of fabric right sides together and with the hems facing up. Pin and sew together the three unfinished sides. Turn the cushion cover right side out. Sew two or three ribbons on each side of the opening as a fastening.

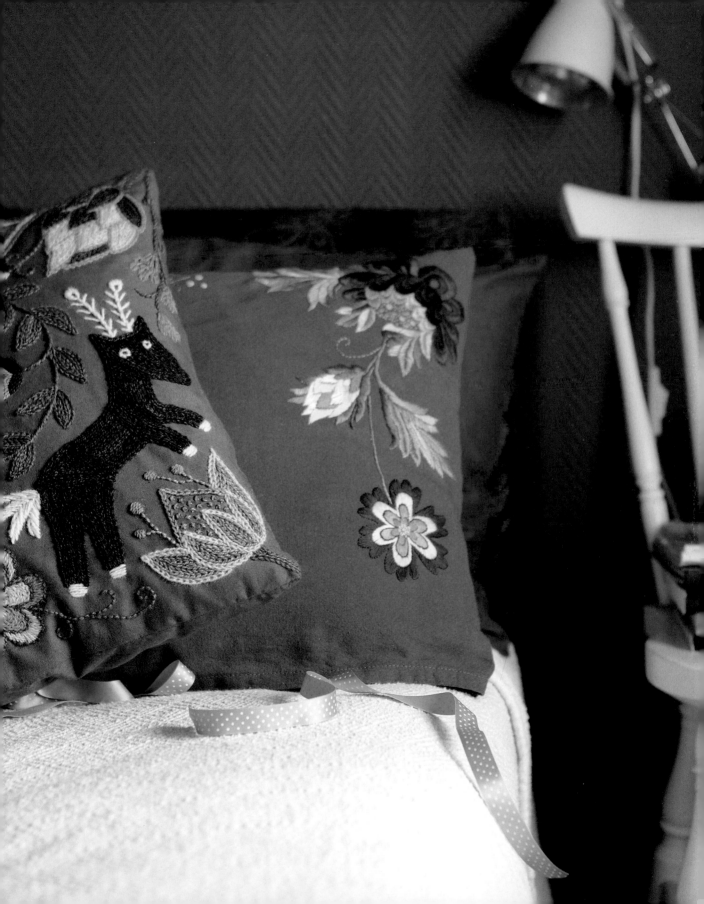

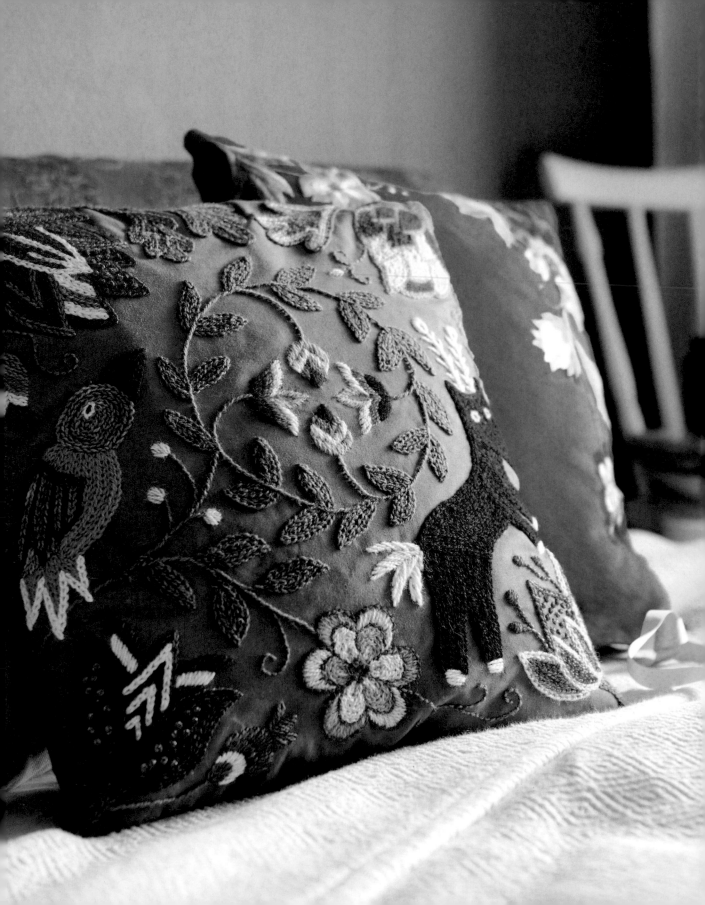

ÖSTERLEN GARDEN CUSHION

Scanian woollen embroidery should really be embroidered on woollen fabric or broadcloth, but this is expensive and sometimes hard to find. You can get nice results, though, by sewing with woollen thread on cotton fabric. It might be wise to consider choosing slightly sturdier fabric, especially if you'll be embroidering with thick woollen thread. The embroidery will pull more tightly than when you use cotton thread, but if you stretch it out well afterwards, it'll become smooth and even, so don't panic!

Technique: Scanian woollen embroidery
Materials: ◎ woollen thread in different colours
 ◎ dark blue cotton fabric, three pieces: 40 x 40 cm (for the front), 40 x 31 cm and 40 x 21 cm (for the back)
Design: See page III

Instructions: zigzag stitch around all the edges. Hem one of the long sides of each of the two back pieces by folding the edge over twice, so that the zigzag stitch is hidden. Pin and sew on a machine.

Transfer the design using a white marker pen. Fill in the shapes using chain stitch, satin stitch, stem stitch, backstitch and French knots.

Stretch the finished embroidery on a wooden block according to the instructions on page 88. Allow to dry and untack later, carefully.

Place the front piece so that the right is side facing you. Lay the shorter of the two back pieces on top, right side down, and with the unhemmed long side aligned with a long side on the front piece. Then place the larger back piece on top so that the back pieces overlap. Pin all around and sew together on the machine. Turn the cushion cover right side out and stuff with a cushion pad.

Note: the cushion case can of course be closed with a zip instead, if you want, but I find it's difficult to insert zips neatly. These two methods (overlap or ties) are easy to do, require no special pressing and the one with the ribbon makes the cushion look extra snazzy!

MODERN BLACKWORK TABLE RUNNER

The geometric shapes of blackwork are perfect for creating more modern patterns. Borrow details from traditional designs, change the scale and shapes and create stitching that feels contemporary rather than traditional.

Technique: Blackwork
Materials: ◉ black DMC mouliné stranded cotton
 ◉ even-weave linen 10 threads/cm, 34 x 74 cm, final measurement 30 x 70 cm
Design: See page 112.

Instructions: zigzag stitch round all the edges, to prevent the fabric from fraying. Measure carefully to mark the centre, and embroider filled and half-filled squares using the design on page 112 (and the picture here), using two strands of cotton thread. The squares are stitched by counting threads: a cross stitch is sewn over two threads in the weave. When all the squares are embroidered, draw the lines of the edge with a pencil or water-soluble pen and then embroider these in backstitch. Fold over the edge of the fabric twice all around, and hem the runner. The finished measurement should be approx. 30 x 70 cm. Iron the runner evenly.

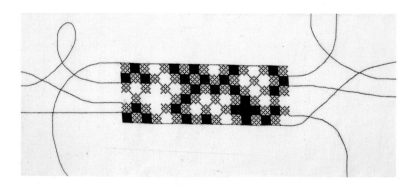

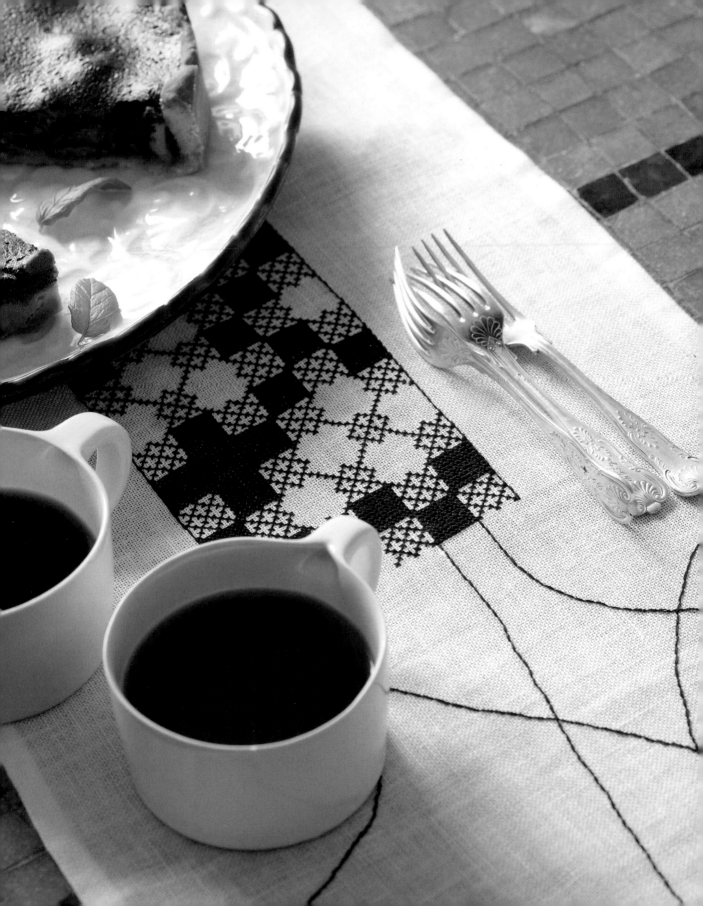

PINK WREATH TABLE MAT

It's fun to study traditional embroidery and create your own designs from it. This table mat borrows flowers from Järvsö embroidery, but the leaves and dots are my own idea.

Technique: Järvsö embroidery, surface satin stitch
Materials: ◉ pink cotton thread, e.g. DMC embroidery thread
 ◉ linen or cotton fabric, 38 x 38 cm
Design: See page 112.

Instructions: zigzag stitch along all the edges. Measure carefully to find the centre and transfer the design around that. Work surface satin stitch and stem stitch using two strands of thread. Hem the finished mat by folding the edge twice, pin and sew on the machine. The final measurement should be approx. 34 x 34 cm. Iron the mat evenly.

TRADITIONAL BLACKWORK TABLE MAT

Blackwork is traditionally sewn with black silk. If you don't want to spend a fortune on your table mat, black stranded cotton works just as well. Sew using one or two threads for different effects.

Technique: Blackwork
Materials: ◉ black DMC mouliné stranded cotton
 ◉ even-weave linen 14 threads/cm, 37 x 57 cm
Design: See pages 15 and 113.

Instructions: zigzag stitch along all the edges to stop the fabric from fraying. Measure carefully to mark the centre, transfer the design and stitch using one or two strands of cotton. Sew the squares by counting threads; sew one stitch over three threads in the central designs and over four on the border.

Fold the edge of the fabric twice and hem. The final size should be approx. 33 x 53 cm. For how to sew hem stitch, see page 93. Iron the mat evenly.

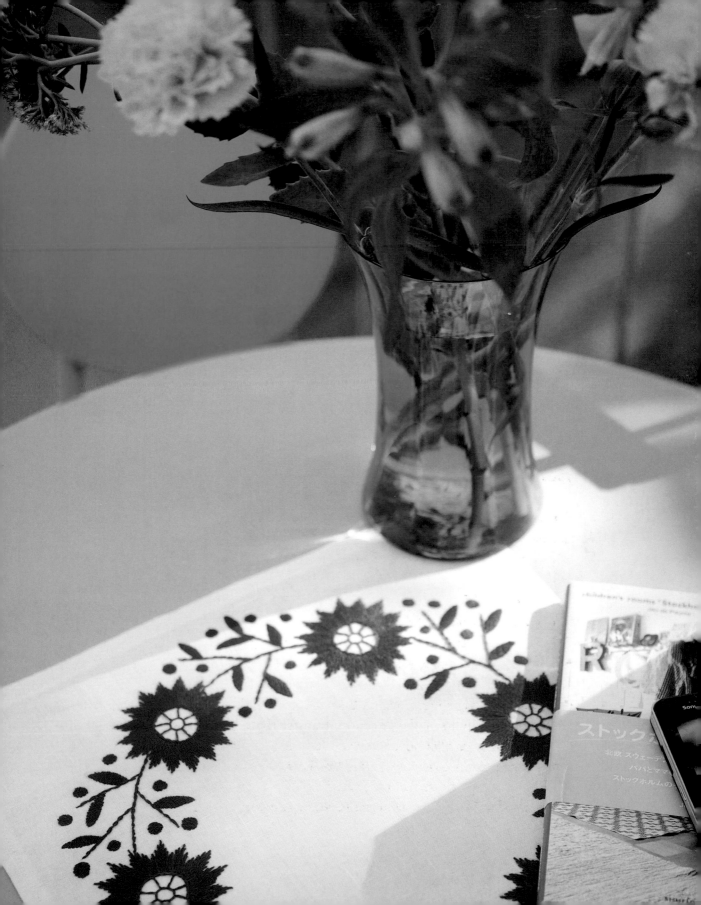

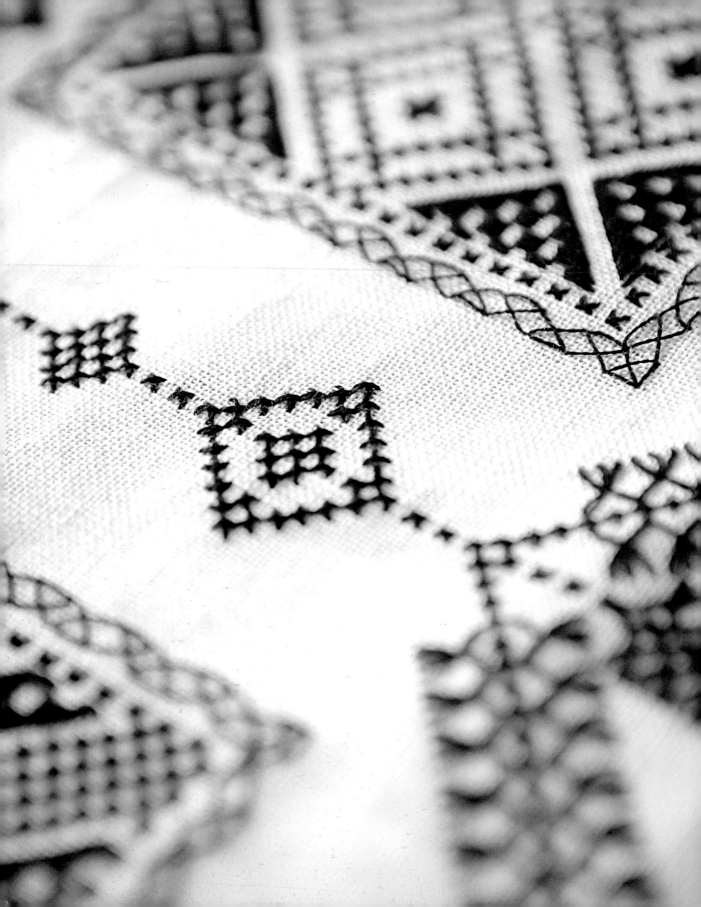

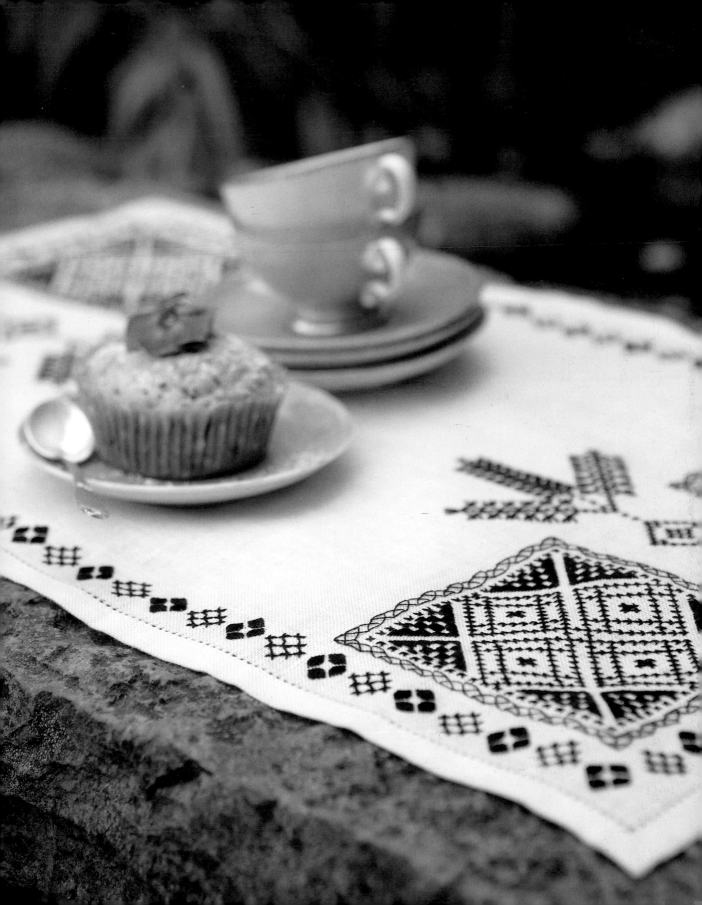

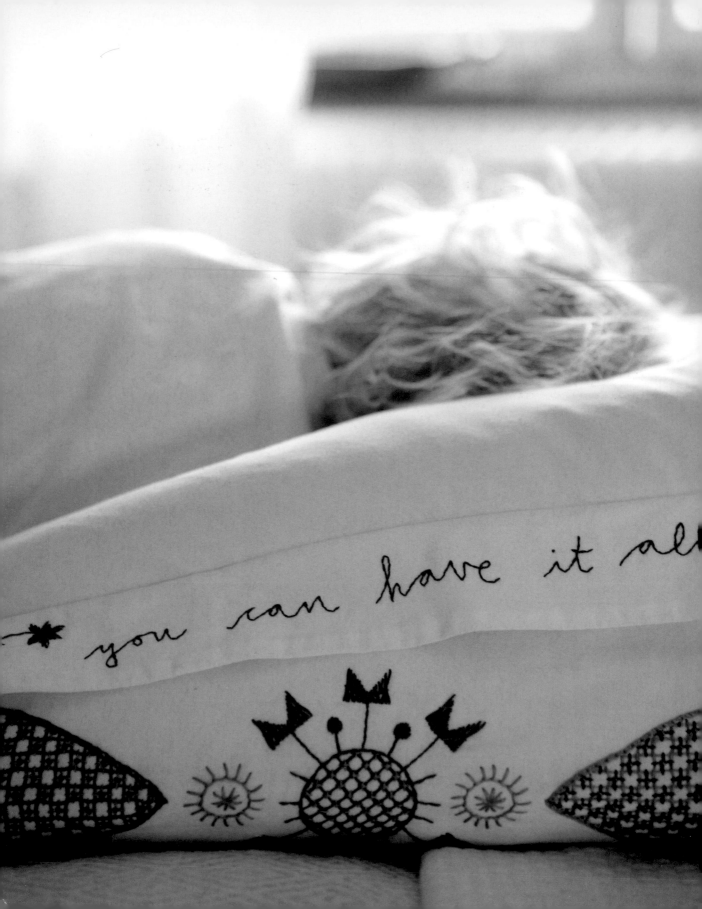

YOU CAN HAVE IT ALL PILLOWCASE

This pillowcase has a border around it, perfect for embroidering. I've included text, even in this Anundsjö design – you can at least be allowed to dream about having it all. Also see the picture on the next page for a more complete image of the pillow's design.

Technique: Anundsjö stitch
Materials: ◉ red DMC mouliné stranded cotton
 ◉ a white Oxford pillowcase
Design: See page 114.

Instructions: Transfer the design to the border around the pillow. If you want to include text, save a spot where you can write it. Work Anundsjö stitch with two strands of cotton thread. Iron the pillowcase evenly.

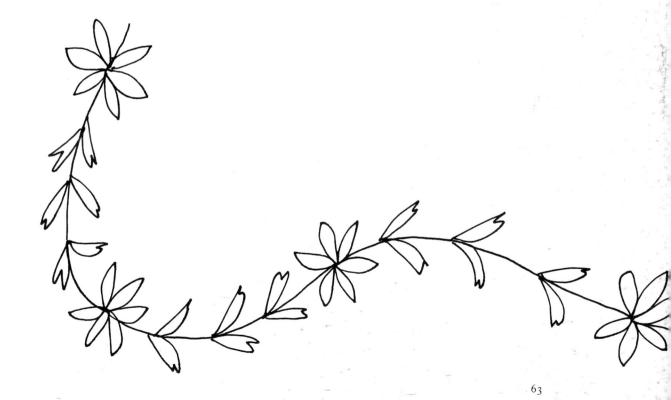

TWO HEARTS PILLOWCASE

One of the most popular things to sew Halland embroidery on traditionally is a pillowcase (*pudevar* in Swedish). The embroidery is placed on the side of the 'pudevaret' that faces the room. Fortunately, when it's only on the edge of the pillow, the stitching does not wear so much. It was common for embroiderers to sign the year and their maiden name, in my case Karin Rogersdotter.

Technique:	Halland embroidery
Materials:	⊚ red and blue DMC mouliné stranded cotton
	⊚ a white pillowcase
Design:	See page 114.

Instructions: transfer the design onto one end of the pillowcase. Work Halland embroidery with two or three strands of cotton thread, depending on the degree of coverage you want. Use a frame, especially for the laid filling stitch. Iron the pillowcase to remove the marks left by the frame.

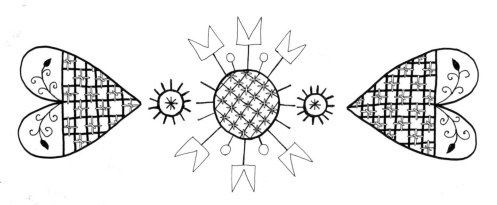

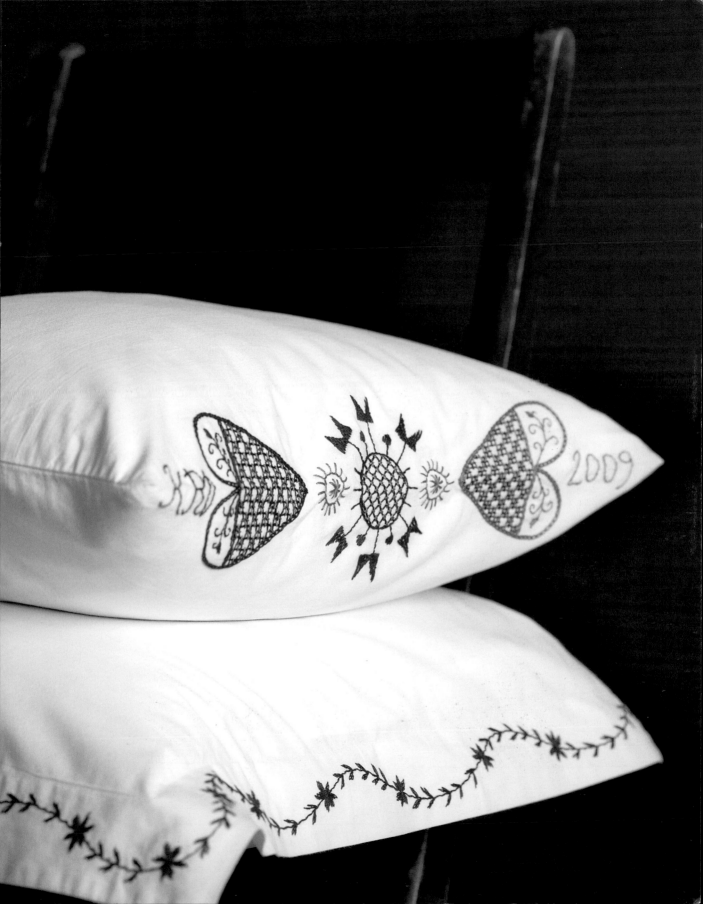

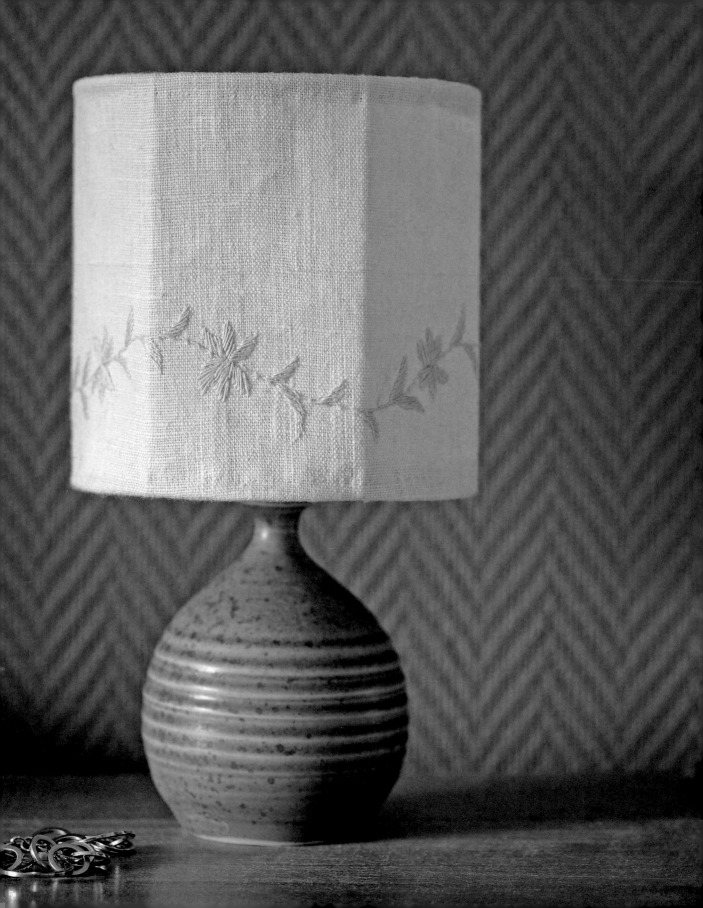

LINNEA LAMPSHADE

Making a lampshade is easier than you think, and the result often looks much better than the lampshades for sale in shops. This one is sewn using faded pink thread on coloured linen, giving a slightly more romantic feeling than traditional Anundsjö embroidery.

Technique: Anundsjö stitch
Materials: ๏ DMC mouliné stranded cotton in any colour
 ๏ linen or cotton fabric, enough to cover your lampshade
 ๏ a lampshade frame
Design: See page 115.

Instructions: measure the lampshade frame to work out how much fabric you will need, and adapt the design to that. Trace the design onto the fabric. Work in Anundsjö stitch using two strands of cotton thread. Press the fabric with an iron until it's smooth. Then fold it, right sides together, and sew into a tube shape. Turn the fabric right side out. Insert the frame into the fabric tube. Fold a seam allowance and sew together by hand using small running stitches, first along the bottom edge, then stretch the fabric evenly, pin and sew together at the top.

TURTLE DOVES FRAMED EMBROIDERY

In Blekinge embroidery, a common motif is sweet little birds flying around among romantic flowers. I think this can sometimes be a bit over-cute, so these birds have got a little more weight to them!

Technique:	Blekinge embroidery
Materials:	◉ cotton thread in several shades of pink and blue, e.g. DMC embroidery thread
	◉ linen or cotton fabric, approx. 32 x 40 cm
	◉ a frame for mounting
Design:	See page 115.

Instructions: zigzag stitch around the edges of the fabric. Transfer the pattern to the centre of the fabric. Using an embroidery frame, work Blekinge embroidery with two strands of cotton thread, preferably mixing threads of different colours for extra effect.

Press the finished embroidery and mount in the frame.

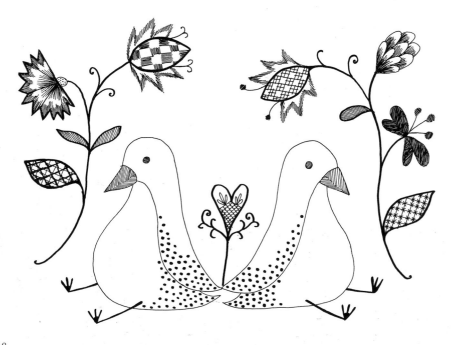

TREE PINCUSHION

A pincushion is an absolute necessity for an embroiderer. It holds your pins and needles in place and you don't run the risk of pricking yourself. It's filled with linseeds, to keep it steady on a table.

Technique: Woollen embroidery using chain stitch, satin stitch, French knots and backstitch

Materials: ◉ woollen thread in different colours
 ◉ broadcloth or another solid woollen fabric, two pieces 16 x 16 cm
 ◉ thin cotton fabric, two pieces 16 x 16 cm
 ◉ linseeds for filling

Design: See page 116.

Instructions: cut the two pieces of cotton fabric so that they are a few millimetres smaller than the woollen cloth. Sew the two pieces of cotton fabric together on the machine to make an inner cushion, leaving a small hole through which you can pour in the linseeds. Turn right side out. Don't fill the inner cushion too full: aim for the woollen fabric to fit over it with a centimetre of seam allowance all round. Sew up the opening by hand.

Draw the design on the broadcloth with a white marker. Stitch using woollen threads in different colours and thicknesses, but don't use too much thick thread, as the design is quite small.

Next, place the two pieces of broadcloth right sides together. Pin and sew together on the machine, but leave a bigger opening than you did on the inner cushion, which should now be stuffed into the woollen cushion. Fold in the seam allowance, pin and sew together by hand, using small, tight stitches.

PEONY SMALL HANDBAG

I got this little handbag from a friend, who thought I should have it. Maybe she realised I would make something more of this simple red, hemp bag. It wasn't long, in any case, before it was covered in flowers.

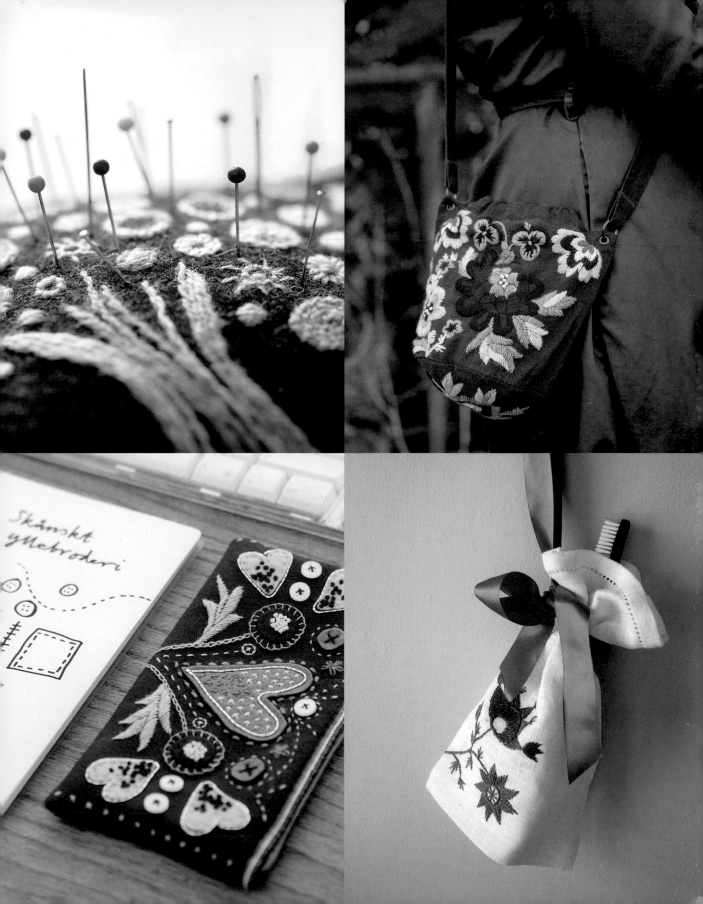

Technique:	På embroidery
Materials:	◉ woollen thread in different colours
	◉ a small bag made of linen, hemp or other fabric
Design:	See pages 99–100.

Instructions: transfer the design to a piece of cardboard or strong paper and cut out the templates. Place them on the bag and draw along the lines using a water-soluble pen or a pencil. Work På embroidery, starting with the bigger flowers and then filling in the gaps with stems and leaves. Fasten off all threads carefully.

LOVE PENCIL CASE

Carry around your pens and erasers in this sturdy case made of colourful cloth. Alternatively, keep your scissors, tape measure and the threads you're currently using in it: it's perfect if you want to embroider on the move.

Technique:	Scanian woollen embroidery and appliqué
Materials:	◉ homespun, broadcloth or other sturdy woollen fabric, approx 22 x 22 cm
	◉ crafting felt, woollen thread, silver thread, buttons and zip
	◉ any ribbon
Design:	See page 117.

Instructions: fold the fabric down the middle. Cut out pieces in broadcloth or crafting felt (the latter is a little thinner and easier to sew), in hearts, circles or similar. Arrange these on the front in a pattern you like, pin them on and stitch using running stitch or blanket stitch. Decorate around them using satin stitch, chain stitch, running stitch, French knots or whatever you fancy. Sew on the buttons and fasten the silver thread with couching.

When the embroidery is done, fold the fabric right sides together and sew up the two ends. Pin the zip in place, and sew using backstitch about ½ cm from the edge. You can hide this stitching with a ribbon. It's a little extra fuss but it looks very nice!

Note: If you're ambitious, you could also put the design on the back.

PINK CARNATIONS LITTLE BAG

You can never have enough small bags for keeping jewellery, hairpins, or other little things in. This one features hem stitch and a satin ribbon to tie up the top of the bag with, but you can choose which details you want yourself.

Technique:	Järvsö embroidery
Materials:	◎ pink cotton thread, e.g. DMC embroidery thread
	◎ white linen fabric, 16 x 48 cm
	◎ satin ribbon, approx. 42 cm long
Design:	See page 117.

Instructions: zigzag stitch around all the edges. Fold the fabric in two. Trace the design with a pencil or water-soluble pen so that it ends up right over the fold. Draw the stem so that it goes right to the edge of the fabric. Stitch Järvsö embroidery using two strands of cotton thread.

Now fold in 1 cm along each short side, then fold again so that the zigzag stitch is hidden and you have a 1 cm hem. Pin. Sew hem stitch as follows: carefully cut 3–4 threads in the fabric, parallel with the edge of the hem and exactly next to it. Pull out the threads. Sew a couple of small stitches using sewing thread on one end of the hem, wind the thread once or twice around three threads in the fabric and then make a new stitch in the hem. Continue like this all the way along. The threads in the fabric will pull together and form small holes. Do the same along the other edge. (See also page 93.)

Now fold the fabric right sides together and pin along the long sides. Fold the ribbon twice and pin it on one side, approx. 4 cm from the upper edge. Sew up the bag on the machine or by hand using running stitch. Turn it right side out and tie up with the ribbon.

Note: in order to prevent the satin ribbon fraying, you can burn it carefully at the end. The fabric will melt and form a tapered edge. Note that this does not work on cotton or linen ribbons, only on synthetics.

NISHIN PURSE

Scanian woollen embroidery often features animal motifs, such as horses, deer and lions. The blue-green woollen threads suggest associations with the sea, so here I have used a fish motif instead, taking inspiration from Japanese prints. *Nishin* is the Japanese word for herring.

Technique: Woollen embroidery using chain stitch, satin stitch, French knots and backstitch

Materials:
⊚ woollen thread in different colours
⊚ homespun, broadcloth or another sturdy woollen fabric, approx. 14 x 33 cm
⊚ a zip, approx. 15 cm

Design: See page 118.

Instructions: homespun and broadcloth don't fray, so, as a rule you don't need to zigzag stitch around the edge. Draw the design with a water-soluble pen or a pencil. Embroider woollen embroidery using one or two strands of woollen thread, depending on the thickness.

Stretch the embroidery according to the instructions on page 88 and allow to dry. Remove the drawing pins and cut approx. 1 cm around, to remove the holes left by the pins. Fold the embroidery right sides together and sew up the sides and bottom edge. Fold over a narrow hem at the top and sew in the zip by hand. If you like, sew on a sturdy ribbon as a handle.

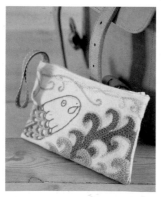

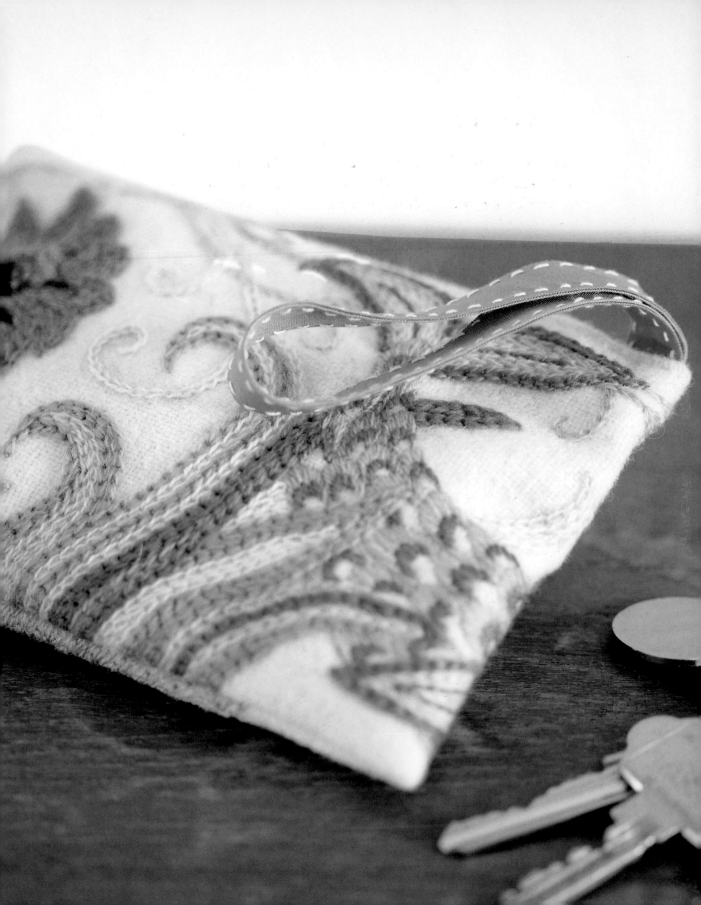

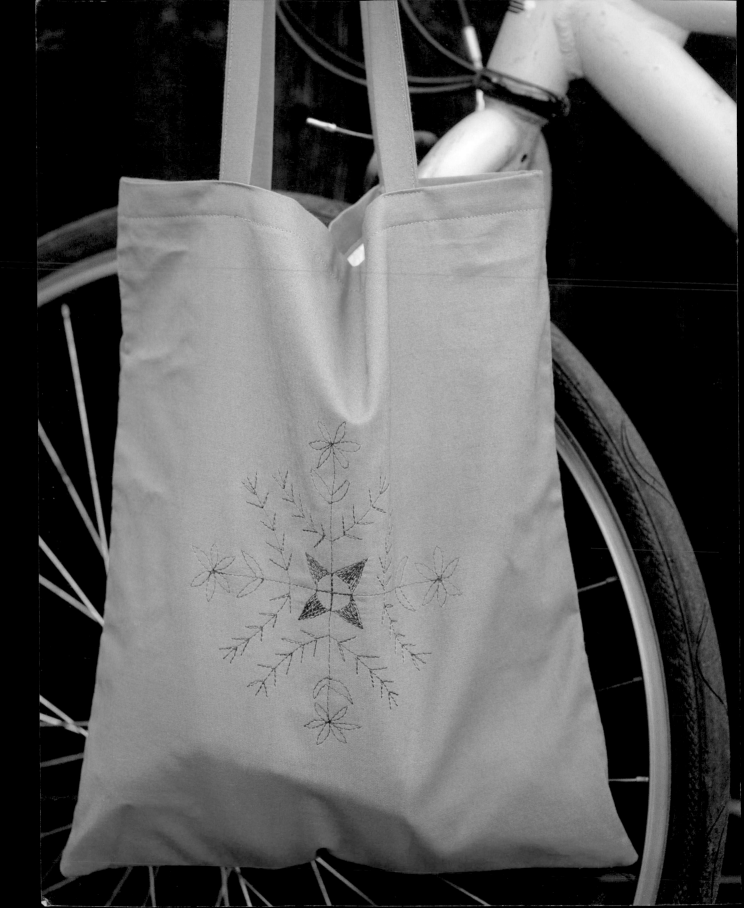

BRITA-KAJSA RECYCLED SHOPPING BAG

This fabric bag has an authentic Anundsjö design, created by Brita-Kajsa herself. But in order to add something personal, I chose to sew the design on the machine instead, and it's also faster this way. When you embroider on a machine, it's good to use a support fabric underneath to prevent the fabric from pulling. Just be sure to pin the two fabrics together properly.

Technique: Anundsjö stitch
Materials: ◎ red sewing thread
 ◎ cotton fabric, two pieces 32 x 41 cm, two pieces 6 x 68 cm
 ◎ lining fabric, two pieces 32 x 38 cm
 ◎ a piece of sheeting (bigger than the embroidery itself)
Design: See page 119.

Instructions: zigzag stitch round the edge of all the fabric pieces. Transfer the design to the centre of one of the larger pieces of cotton. Tack the sheeting to the back, ensuring that it covers the area you are going to embroider and that it is flat. Sew all the straight lines of the design using straight machine stitch. You can fill shapes by sewing a straight line, then turning and sewing back again right beside the first line, until the stitching fills the outline. Take any thread ends from the right side of the work through to the back of the fabric and fasten them off. Cut away any surplus of support fabric.

 Assembling the bag: place the lining pieces right sides together and sew together along two long sides and one short side, leaving 1 cm seam allowance. Press seams flat. Do the same with the outer fabric. Turn it right side out so the embroidery faces outward. Now insert the lining into the outer, fold over the top edge and pin. Put this aside while you sew the handle. Fold these pieces of fabric double along their length and press, then fold the edges in again and iron. Each handle should now be 1.5 cm wide. Pin and sew straight stitch along the long sides, as close to the edge as you can. Make a crease approx. 2 cm from each end. Position each crease under the hem on the top edge of the bag and pin. Ensure that the handles are placed symmetrically on the two sides of the bag. Now sew around the top of the bag, approx. 1.5 cm from the edge. Strengthen with a few extra stitches on each handle.

WINTER ROSEHIP MITTENS

I'll admit that it's a little tricky to stitch on ready-made gloves, but it's worthwhile. The result is like jewellery and it's not surprising that embroidered mittens were traditionally used in weddings, especially in Dalarna. This example is made of grey broadcloth, but it's just as easy to embroider on knitted mittens. Just remember that they must be finely knitted for the embroidery to be shown off to its best advantage.

Technique: På embroidery
Materials: ⊙ woollen thread in different colours
 ⊙ a pair of mittens
Design: See page 120.

Instructions: measure the mittens carefully to locate the centre. Transfer the design using a marker pen so that it ends up in the middle of the back of the hand. You might need to go back over the design later if it wears off, as you will probably erase it with your fingers while stitching. Keep one hand on the mitten and try to hold the fabric as evenly as possible. Keep a light touch when you're sewing and don't pull the thread too tight. When finished, turn the mitten inside out and fasten off all the threads.

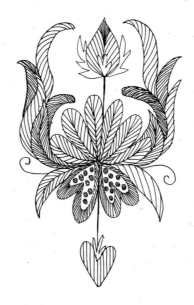

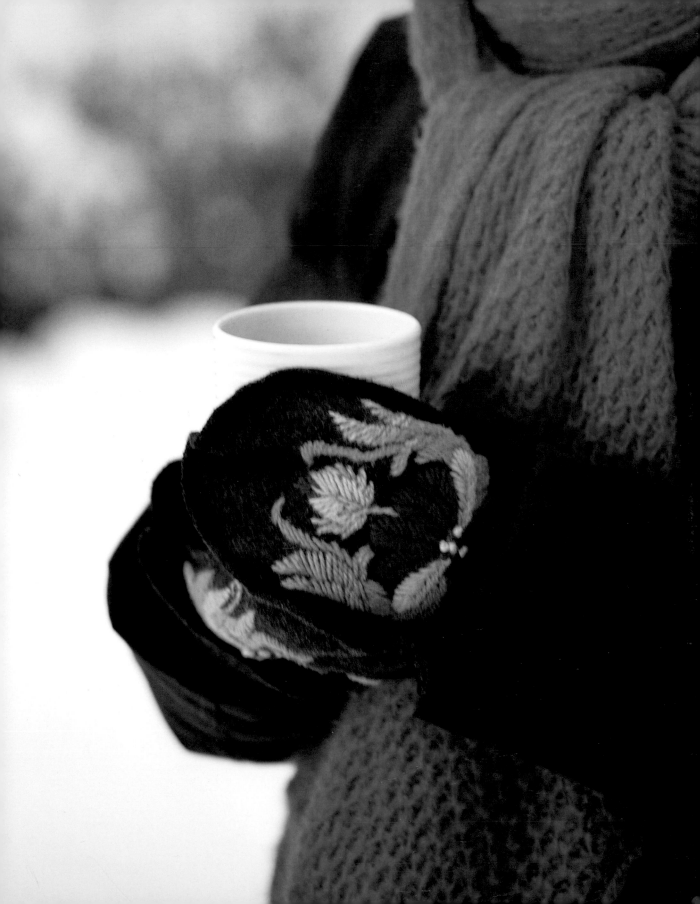

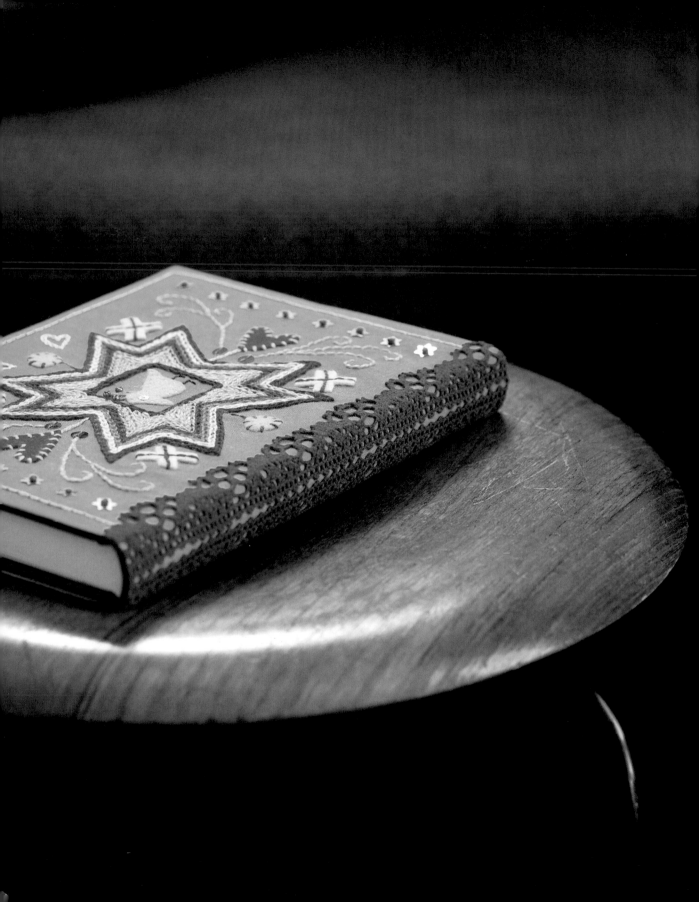

SCANIAN BIRD NOTEBOOK COVER

I don't quite know what to call this notebook cover – folkloric perhaps? It includes a mix of all possible types of materials and colours. The star motif, at any rate, is usually found on southern Swedish textiles.

Technique:	Chain stitch and appliqué
Materials:	⊙ cotton fabric
	⊙ broadcloth or crafting felt
	⊙ linen thread
	⊙ sewing thread
	⊙ lace
	⊙ sequins
	⊙ a notebook
Design:	See page 121.

Instructions: put the notebook on the fabric and mark a 1 cm seam allowance along the short sides plus 8 cm along each long side. Cut out and zigzag stitch around the edge of the fabric. Fold the fabric in two and draw the design on the front with a water-soluble pen or a pencil. Embroider the star shape in chain stitch. Pin on the lace so that it ends up along the spine of the book; sew it on using small stitches. Cut out a bird, heart, circles or other shapes from the crafting felt and sew them on. Decorate further with embroidery and sequins. Iron the finished embroidery on the reverse.

Fold in the 1 cm hem on the short sides and press. Wrap the fabric around the book and fold in the 8 cm hem on the long sides. Sew it up at the bottom and the top with small, tight stitches, on the front and the back.

MATERIALS

There are actually very few restrictions where embroidery materials are concerned. You can embroider on most fabrics, using many threads, as long as you have the right type of needle. Most importantly, your needle needs to be sufficiently thick, as it is this, not the thread, which will make holes in the fabric. As long as you have the right needle, you can sew with thick knitting yarns, ribbons, strings or fine sewing thread, on cotton fabric, linen, velvet or even paper. Check what you have at home already before you go out and buy what will, unfortunately, be quite expensive specialist threads. The main purpose of this book is to inspire you to do your own embroidery, so feel free to be innovative and try a new approach!

If you still want to follow the embroidery designs in this book to the letter, I have used the following materials:

Threads

DMC mouliné stranded cotton: a mercerised cotton thread, which means it's more lustrous than normal cotton. You can find it in most thread, fabric and craft shops and it is available in an array of colours. You buy it in skeins, and each thread is made up of six strands. You can use as many strands as you want in order to get a fuller or thinner embroidery. Mostly, however, two or three are used at a time.

Pearl cotton: also a mercerised cotton thread, but more tightly plied than stranded cotton. Pearl cotton comes in different thicknesses and therefore doesn't need to be divided into separate threads.

DMC embroidery thread: a duller cotton thread which can be divided into two or three strands. This thread covers fabric very well and is best for sewing Järvsö and Delsbo embroidery. Sometimes it can be a little difficult to get hold of in shops, but you can always order it via the Internet.

Klippans linen thread: a Swedish linen thread of good quality and available in many wonderful colours. It is bought in skeins and meant for embroidery. Linen thread behaves slightly differently from cotton: it doesn't lie so neatly on the fabric, and looks more rambling. Good alternatives available outside Sweden are DMC stranded linen and Gütermann linen thread.

DMC tapestry wool: quite a soft, fluffy wool. Can be divided into two strands and used for Scanian woollen embroidery.

Moragarn: a thinner, more tightly twined, yet still soft wool from Sweden. Use a couple of threads together so that it will cover the design well. An excellent alternative available outside Sweden is Appletons 2-ply crewel wool.

Tunagarn: a slightly rougher wool from Sweden. Similar to the thread I used for På embroidery here in this book. Both moragarn and tunagarn are purchased in skeins, which you can wind into balls before stitching with. Good alternatives available outside Sweden are Appletons 4-ply tapestry wool or DMC tapestry wool.

Weaving threads: there are several types of thread which are really meant for weaving but which you can also use for embroidery. The only disadvantage is that you have to buy a whole ball or skein. For basic colours though, like white and red, it can be more economical and worthwhile.

Fabrics

Cotton: the most suitable fabric for embroidery is basic sheeting. Cut up pieces of old sheets or buy it by the metre. And of course it's available in every colour imaginable.

Jersey: this is usually made of cotton, although it can be blended with a stretchy elastane or polyester thread, as in leggings and underwear. Jersey is knitted instead of woven, which is why it's more stretchy. It's a little trickier to embroider on, but 100% cotton jersey is not especially difficult.

Linen: also found in quite a range of thicknesses and colours. What you need to keep in mind is whether your embroidery will be counted or not, i.e. if you have to count the threads. For blackwork, an even-weave linen must be used in order for the design to turn out correctly. For other, more freestyle techniques, any linen fabric will do.

Wool: homespun, broadcloth and woollen upholstery fabric can be purchased in well-stocked fabric shops, and in craft shops, too. It can usually be found in a range of different colours.

EQUIPMENT

The only things you really need when embroidering, apart from fabric and thread, are the following:

Needles: as mentioned, these should be appropriate for the thickness of the thread you're using. The best choice for embroidery is tapestry needles in different thicknesses. They have an oblong, slightly flattened eye through which the thread fits perfectly. For woollen embroidery you need a darning needle that's not too thick. Sewing needles are used for hemming and making up projects, if you don't use a machine. Pins are a must for assembling.

Frame: this makes most embroidery easier. It can be difficult to hold the fabric sufficiently taut without a frame, and it's easy to pull the stitches too much otherwise.

A frame is used as follows: lay the fabric over the smaller ring, ensure the design to be embroidered is positioned in the centre, and place the larger ring on top. Pull the fabric equally in all directions, so that it is evenly stretched, and tighten the screw on the side of the larger ring. When you have finished embroidering the area within the frame, move the frame on for the next bit. I usually use a frame for all types of designs, except for long flowering creepers sewn in stem stitch, where the stitches don't tend to pull much. With these, you're working so quickly that it can feel awkward to be constantly moving the frame.

Scissors: embroidery scissors must be small, pointed and sharp. Do not use them for anything other than fabric and thread, otherwise they will quickly become blunt.

Pens and pencils: a medium-hard, newly sharpened pencil works well for drawing designs on light-coloured fabrics. Keep a light touch when drawing; the marks will usually disappear in the first wash. The idea is that the thread will cover the pencil mark, but if you press too hard with a pencil it will be visible through the thread.

For dark fabrics, you'll need a white or light marker pen. These are available in well-stocked fabric shops. You can also buy special pens whose ink dissolves in water or even just disappears in air after a time.

TRANSFERRING DESIGNS

Use the design sheets at the back of the book for your stitching – either whole designs or just parts; place tracing paper or thin drawing paper over the top and trace. If you feel a design is the wrong size for what you're planning to embroider, you can adjust it first using a photocopier. Either enlarge or reduce the size of the design to the right scale. I really recommend that you then draw all the stitches onto the paper. This helps you plan how you'll fill the design with thread on the fabric. It doesn't need to be exact, but it will give you a feel for how you will do it. Also, look carefully at the photos and drawings in the book to judge how the stitches are placed.

To transfer a design onto fabric, you can proceed in various ways. If you feel comfortable, draw freehand and adjust the design on the fabric you'll be embroidering on. If the fabric is light and not too thick, you can place the drawing underneath and go over the lines with a pen. It can also make things easier to hold the drawing and the fabric up against a window together, or to place everything on a lightbox.

For thicker or darker fabrics, you can make small holes in your drawing paper with a thick needle along all the lines. Then draw over the holes with a white marker. The design will then be visible as small dots on the fabric.

Templates are usually used for På, Järvsö and Delsbo embroidery. Trace the designs from the book, first onto tracing paper and then onto cardboard. Cut out the shapes, place them on the fabric and draw around them.

For Halland embroidery, which is made up of round shapes, use any round things you can find at home: glasses, mugs, candles, etc.

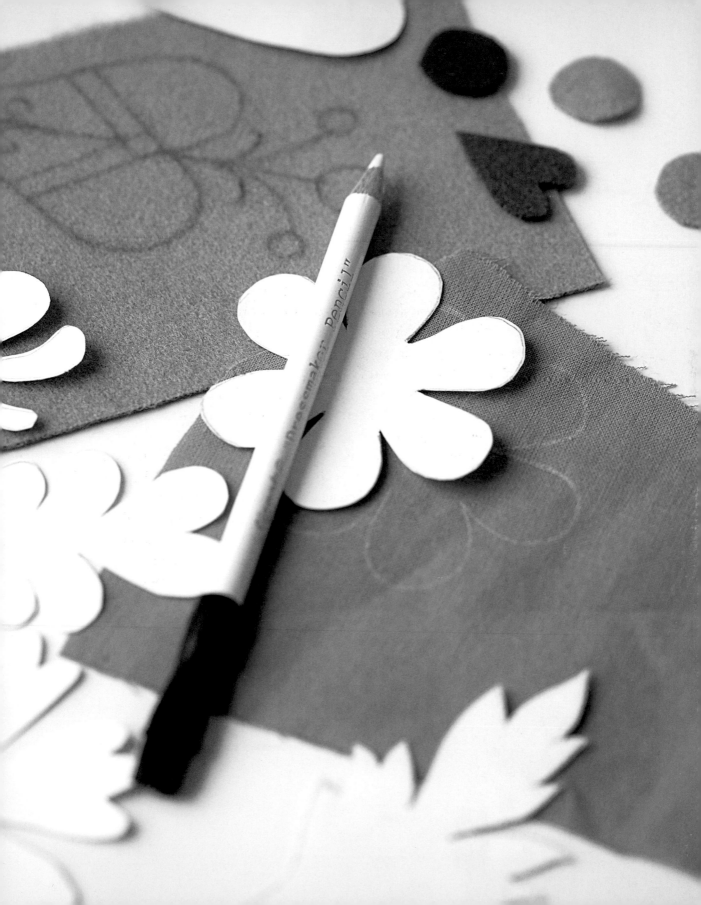

TECHNIQUES AND CARE

When you've drawn a design on your fabric, secured it in a frame and chosen threads, it's finally time to start embroidering! Don't start by making a knot in the thread. Knots can come undone and then little thread tufts stick up in the middle of your embroidery. Instead, pass the needle down a short distance away from where you want to start, pass it up again along your line and fasten the end later. Alternatively, once you've done some stitching and need to change threads, you can fasten on to what you've already sewn. This saves thread and avoids leaving lots of loose ends hanging from the back. Fastening threads is one of the most boring tasks, so it's nice to do it as you work.

It's a good idea to sew from right to left as much as possible. This prevents the thread twisting on itself and can reduce the risk of knots. Also, don't use overly long threads when you embroider, as this increases the risk of knots.

Otherwise, the most important thing to keep in mind is not to pull too tightly. Make a stitch and pull the thread through until the fabric says 'stop'. Follow the lines of the design perfectly. Keep a light touch and try to maintain a rhythm. Don't be picky about every stitch, or you'll quickly lose heart.

Aftercare: for most of the projects in this book, it's enough just to iron the fabric when you're finished. Iron on the reverse, with a damp cloth on top of the embroidery. Woollen embroidery shrinks so it can't be ironed so smoothly. You need to hold it taut so that it stays nice and flat.
Instructions: fasten the finished embroidery tightly to a wooden block, with drawing pins around the outer edge. Ensure that the fabric is completely flat and equally taut all around. Place a damp cloth over the top and leave until dry. You can stretch linen and cotton with pins on an ironing board instead. With this method, the cloth becomes smooth without the finished embroidery becoming too flat, which often happens when pressed with an iron.

Washing: if possible, wash the fabric before you start embroidering. This way it won't shrink later and ruin your work. Most of the pieces in this book can be washed by hand or at 40° in a washing machine. If you want to wash woollen embroidery, choose a wool programme; it's as gentle as washing by hand. Use wool or mild-action detergent for the best results.

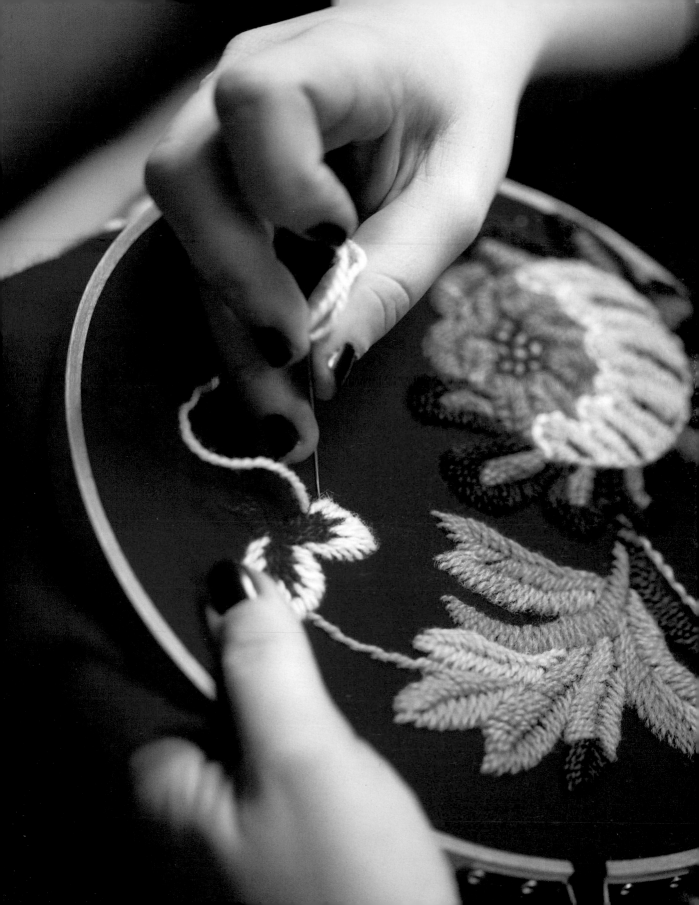

EMBROIDERY TUTORIAL

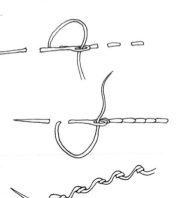

Running stitch: Pass the needle up through the fabric, then pass it down a little further on.

Backstitch: Pass the needle up through the fabric and then down a little further back. Continue so that the next stitch ends where the last one started.

Threaded running stitch: Sew one row in running stitch. On the way back, thread the needle through your stitches instead of the fabric.

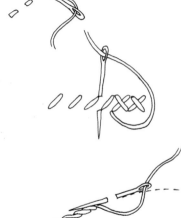

Cross stitch: Sew slanted stitches over a number of threads in the fabric, then go back over them stitching in the opposite direction. Cross stitch is most easily sewn on even-weave linen or Aida fabric.

Stem stitch: Sewn in the same way as backstitch, but here the needle always emerges beside the previous stitch. Ensure that the thread is always in the same direction as the needle when you sew the next stitch.

Chain stitch: Pass the needle up through the fabric and down again next to where it emerged, but don't pull taut. Pass the needle up again a little further away. Place the thread around the needle in a loop and pull through the fabric. Alternatively, if you pass the needle down a little further away from where it came up, you achieve an open chain stitch (or ladder stitch). Chain stitch can also be used to cover large surfaces: simply sew several rows of stitches close together.

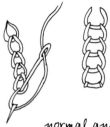

normal and open chain stitch

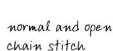

you can also sew flowers

Surface satin stitch:	Pass the needle up along the line you've drawn. Pass it down on the other side of the shape to be embroidered, then come up again directly next to where you went down. Continue in this way along the length of the shape. The thread will now be mostly seen on the front of the fabric.	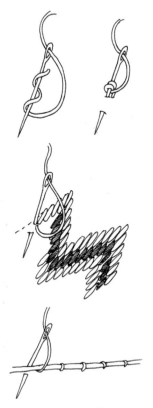 *for round shapes, short and long stitches are combined*
Satin stitch:	Pass the needle up through the fabric and down on the other side of the shape you're stitching, beside the previous stitch. Come up again next to where the needle emerged for the first stitch. The thread now appears on both sides of the fabric which creates more of a raised shape than surface satin stitch.	*leaves can also be sown like this*
French knots:	When the needle comes up through the fabric, wind it two or more times around the thread and pass it down just beside where it emerged. Pull through carefully. Hold the thread gently with your thumb so that you don't lose the tension.	
Long and short stitch:	Sew surface satin stitch or satin stitch diagonally along the line you've drawn. Sew just the right number of long stitches. Continue with a row below, using the same thread or a different colour. This technique is perfect for covering large surfaces or for highlighting pretty colour changes.	
Couching:	Place a thread along the line you're going to sew. Fasten it to the fabric by sewing small, even stitches over the length of the thread.	

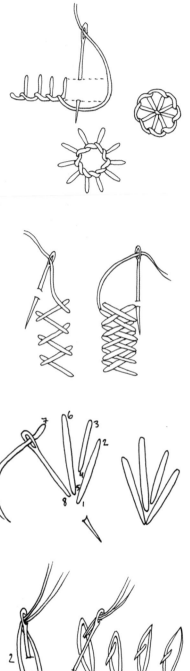

Blanket stitch: Secure the thread at the edge of the fabric and bring the needle up. Pass the needle down at a point on the top line you're following. Pass the needle up at the edge of the fabric, then pass it down again a little further along the first line. Place the thread around the needle and pull through. If you sew in a circle instead, you will achieve a buttonhole stitch. Sew inwards or outwards, depending on the desired effect.

Herringbone stitch: Sew a long, slanted stitch to the left. Sew a very short stitch in the fabric towards you then sew a long stitch again, but this time to the right. If you leave a little gap between the stitches you achieve an open herringbone stitch. If you sew the next stitch right next to the previous one instead, it will be tighter.

Diamond ray stitch: Pass the needle up beside number 1 on the drawing. Pass it down by number 2, up by 3 and so on. Preferably make sure that numbers 1 and 8 end up near each other so that the ray is nice and tight.

Anundsjö stitch: Sew surface satin stitch, but pass the needle up in the middle of the last stitch you did and fasten down one of the threads with a little stitch to the side. You can sew this slanted stitch either to the right or the left. The Anundsjö stitch requires thread that is easily split, or two threads that are not twined too tightly.

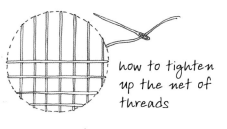

how to tighten
up the net of
threads

*Laid filling
stitch:*
Can be endlessly varied. Start by drawing a shape; a circle is the most common choice. Then stretch out the threads as you stitch them, straight or diagonally, to produce a net effect. Fasten the net to the fabric using different types of stitches; see the diagram for examples. Mix different colours for extra effect. End with a border of chain stitch, backstitch, stem stitch, or similar, to cover the edge. An embroidery frame is an absolute must for this technique! You can also make things easier for yourself by drawing the net lightly with a pencil or water-soluble pen.

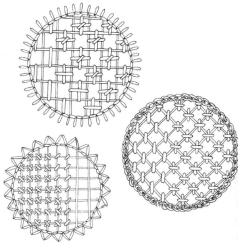

Hem stitch:
Carefully cut three horizontal threads in the fabric parallel with the hem and just beside the hemmed edge. Pull out the cut threads. Fasten a couple of stitches to the fabric, wind the thread once or twice around three vertical threads in the fabric and then sew a new hem stitch. Continue this all the way along the edge. The threads in the fabric will be pulled together and form small holes.

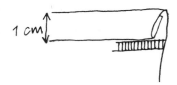

1 cm

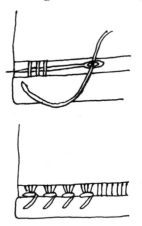

reverse

right side

93

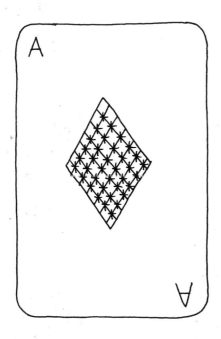

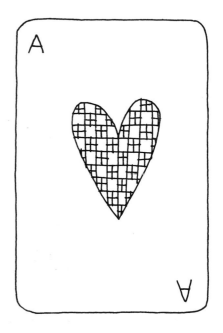

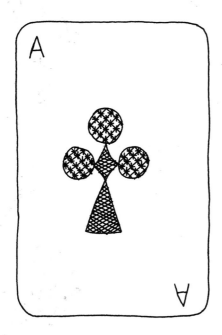

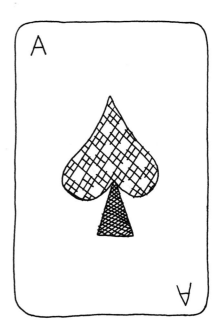

Designs

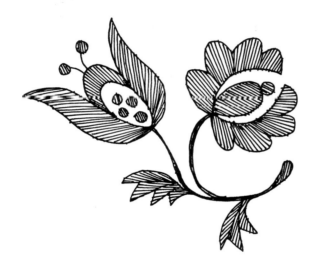

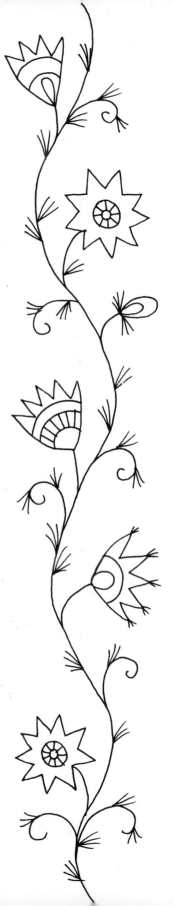

Enlarge or reduce any design in a photocopier to make it the size you need before transferring it to your fabric.

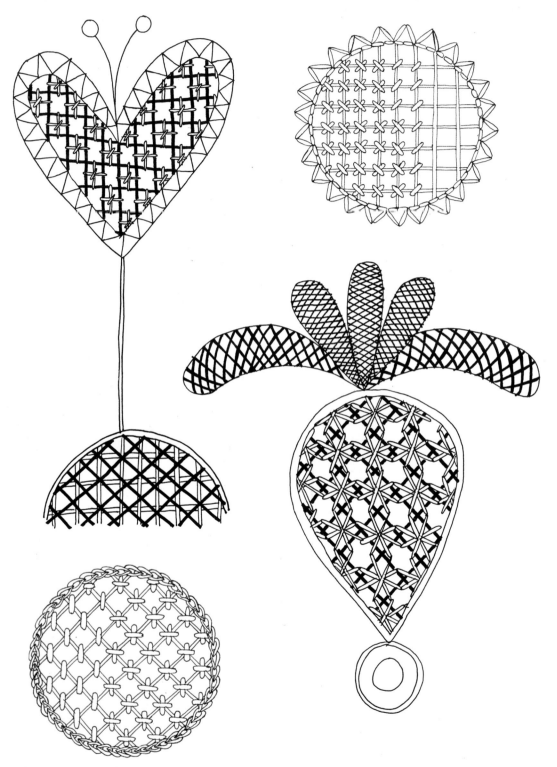

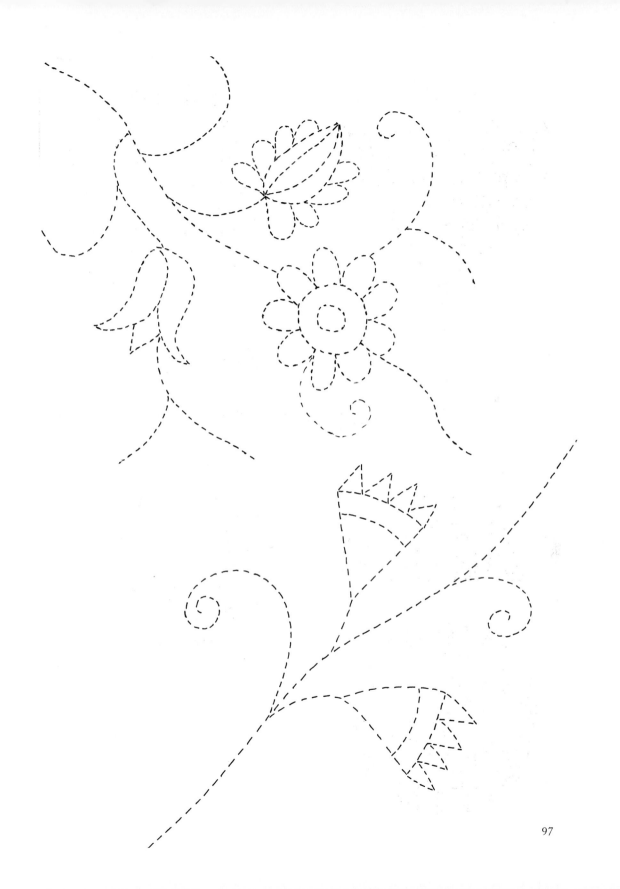

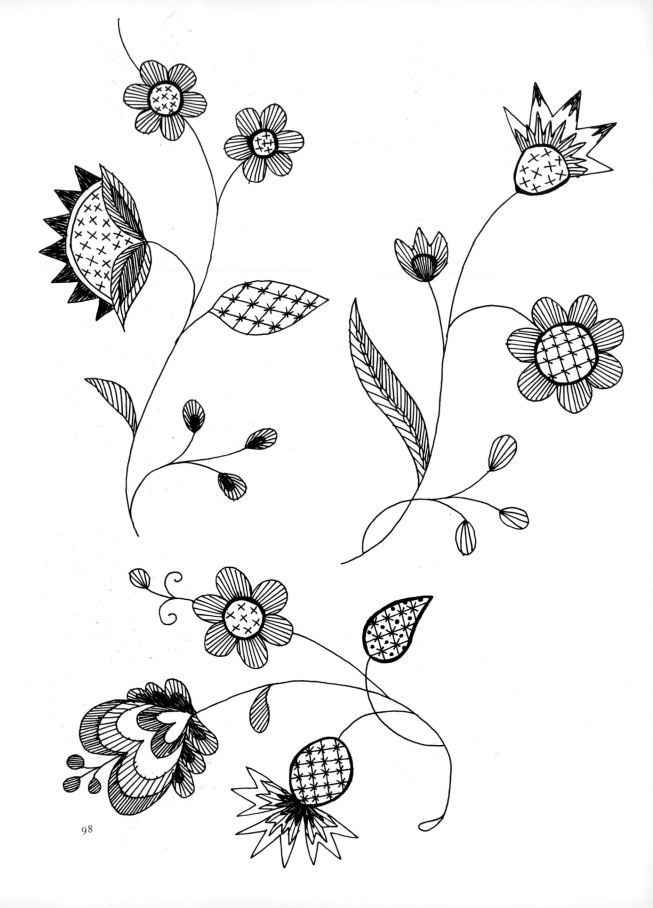

98

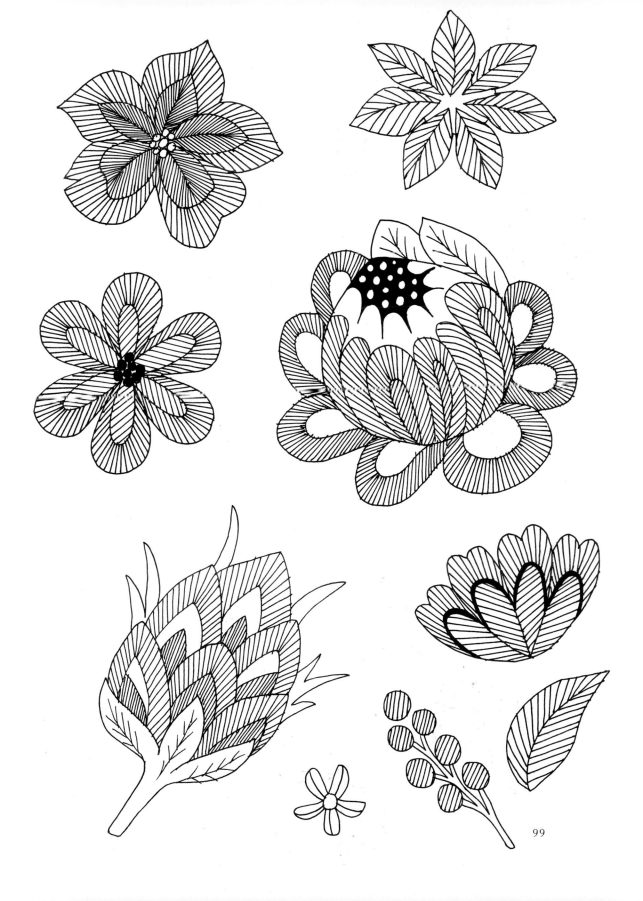

99

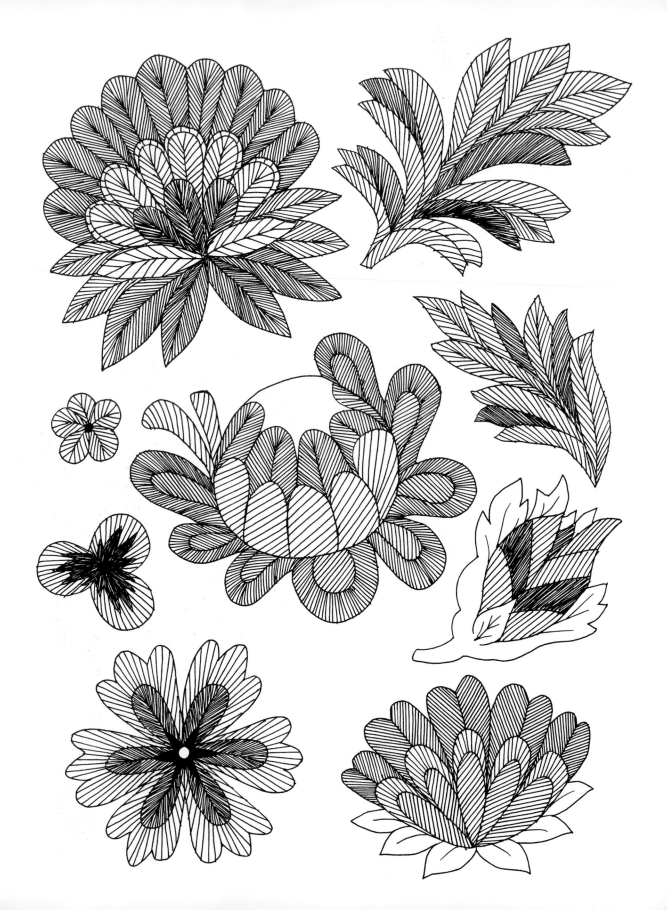

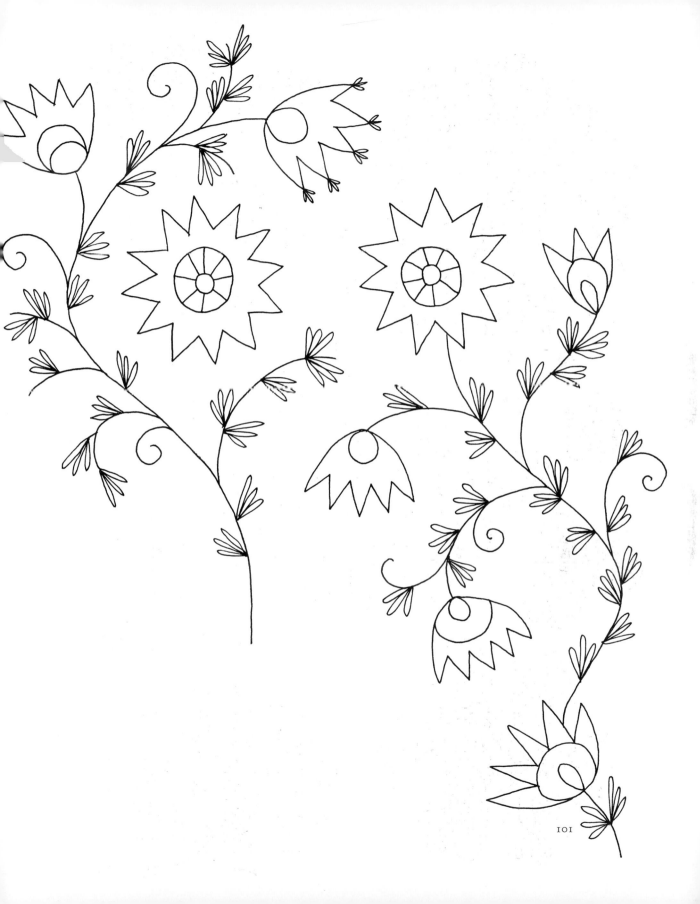

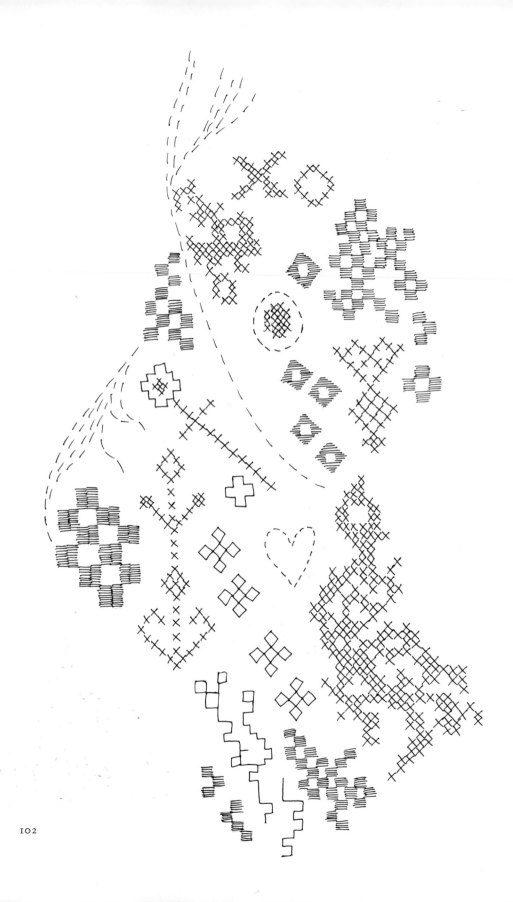

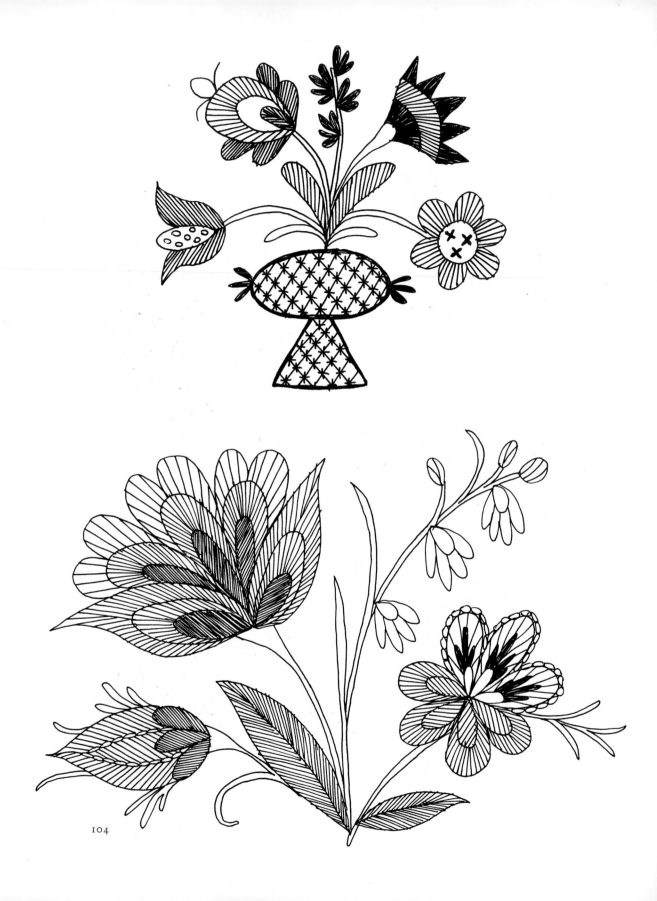

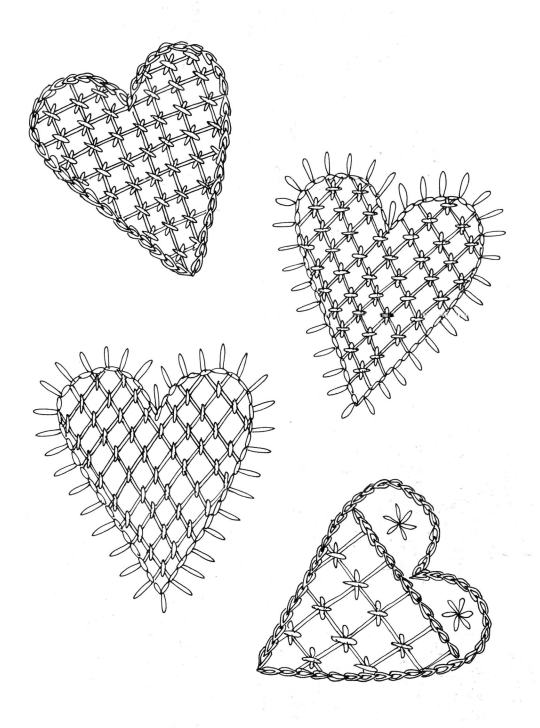

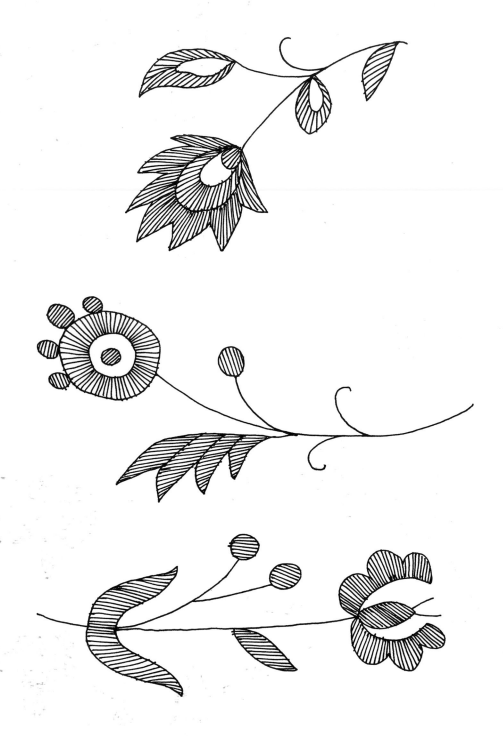

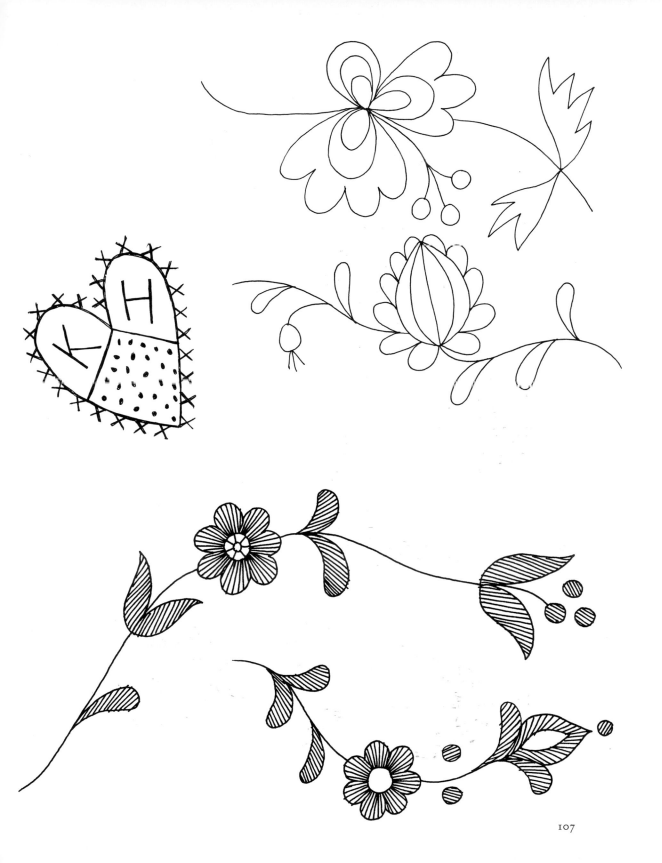

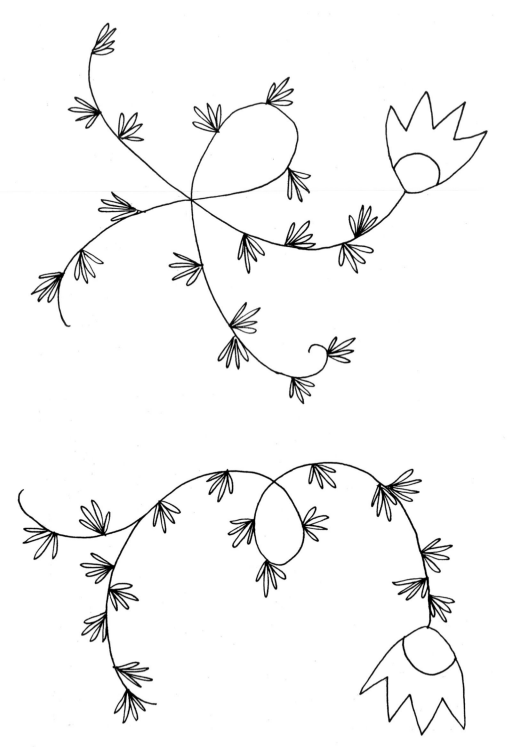

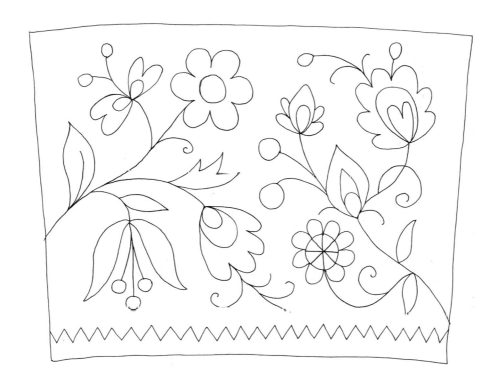

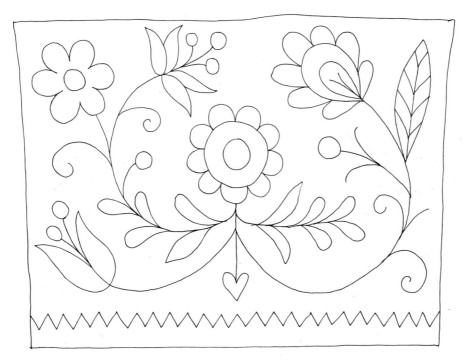

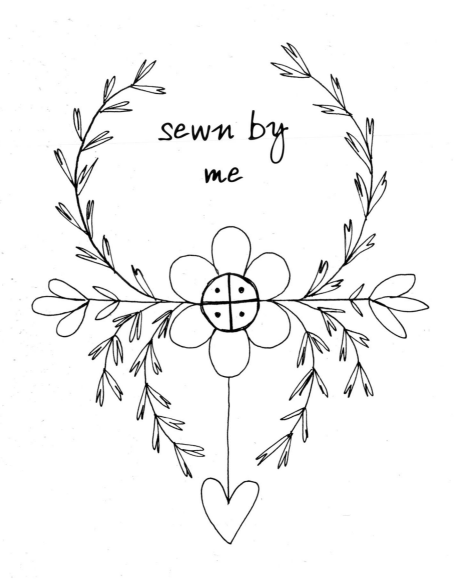

sewn by
me

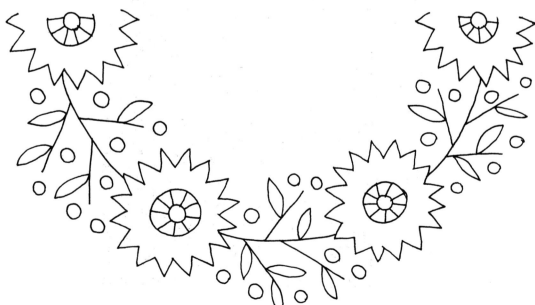

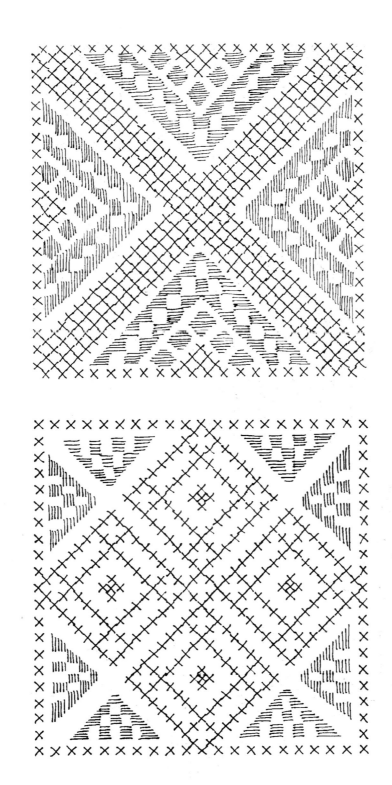

you can have it all

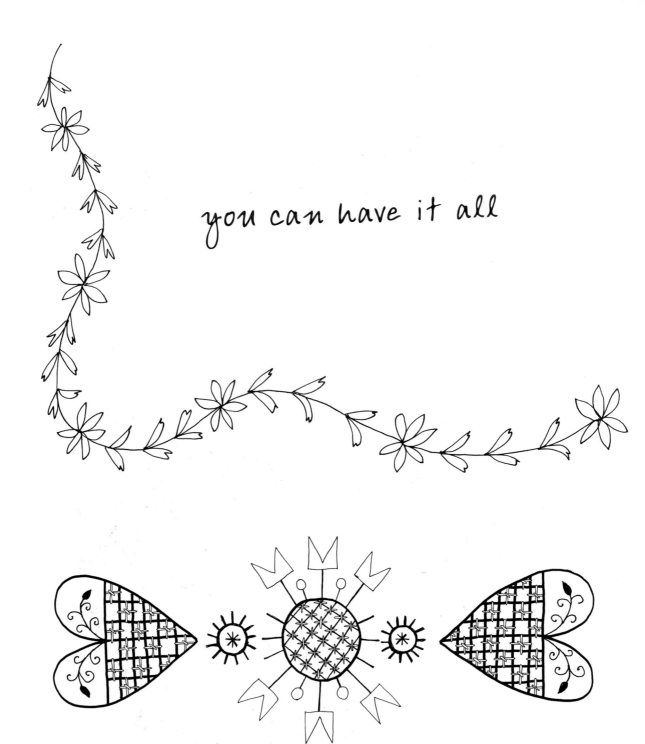

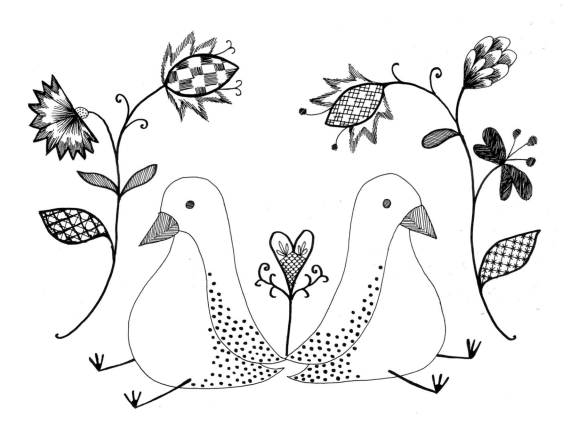

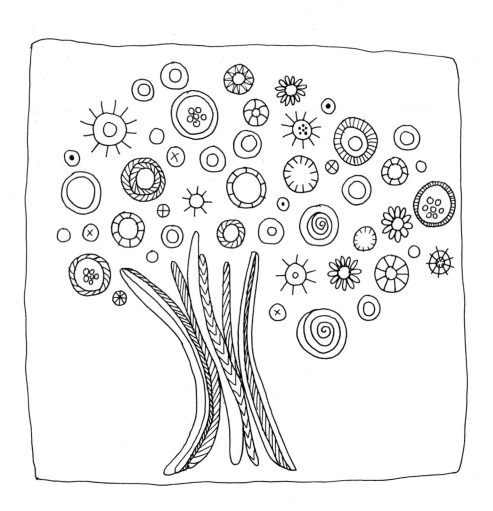

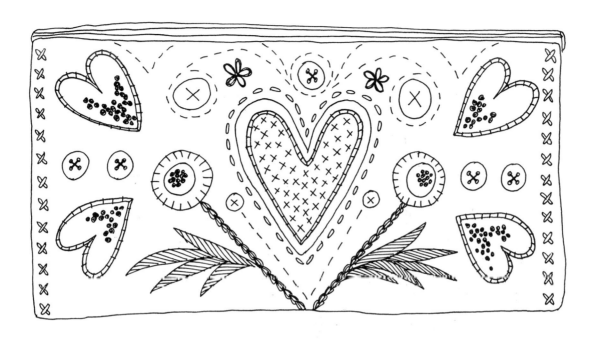

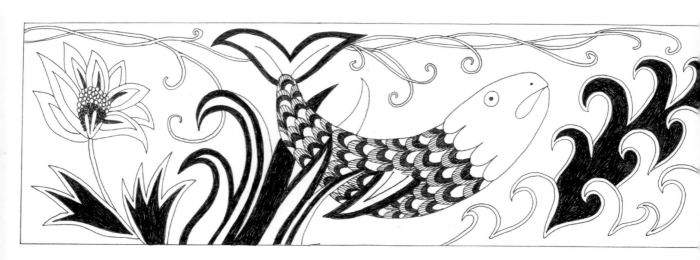

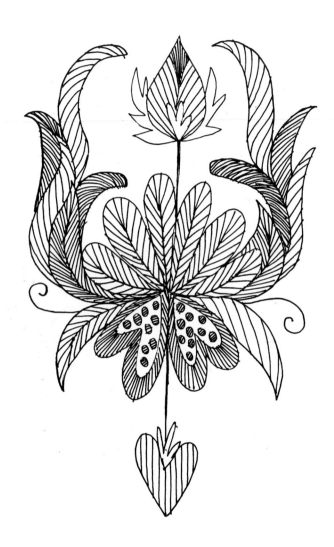

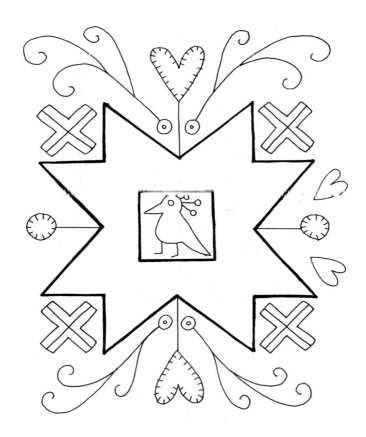

ACKNOWLEDGEMENTS

Eva Kruk: editor extraordinaire! Your ability to put everything together, combined with great belief in me and enthusiasm for embroidery, has been so rewarding. I couldn't have asked for a better project manager.

Karin Björkquist: thanks for a great working relationship and fun collaboration. Your suggestions and ideas for how the pictures should be shot gave the embroideries a whole new (and improved) life. You even made sure we took regular coffee breaks!

Victoria Kapadia Bergmark: so much more than a designer! You kept our spirits up and gave your all, from home-made marmalade to inspiring conversations and lots of laughs. I've had complete faith in you throughout the entire project.

Mum, Dad and Mats: fan club!

Thanks to my teachers and supervisors at HV, who have been with me from the start of everything that eventually turned into this book. Thanks in particular to Carita Landstedt, Gun Aschan and Kim Halle: your advice will stay with me always.

All the models who happily agreed to take part: Mats Holmberg, Emilia Öster, Susanne El Makdisi, Victoria Kapadia Bergmark, Iris Kapadia Bergmark, Louise Björkquist, Owen Hardwicke, Johan Sellén and Malin Nilsson – wonderful that you all wanted to be a part of this!

Finally, I want to thank those lovely friends who in one way or another have been involved in the work on this book: Sarah, Alex, Anna O, Anna S, Kenza, Helén, Bojana, Heléne, Magda, Ottil, Rebecca, Niklas H, Niklas M, Jonas, Erika, Jenny, Gunilla, Mia, Audrey and Frida who blogged, all Irises and all other friends, acquaintances and relatives who came to me with encouraging comments while I was embroidering: it has meant a great deal to me.

And extra warm thanks to Mattias, who wanted his very own hoodie.

SUPPLIERS

A selection of shops and websites with a focus on embroidery. Remember, though, that most sewing shops usually have a reasonable supply of embroidery materials.

UK

Sew and So
www.sewandso.co.uk
Tel: +44 (0)1453 889988
Online embroidery and sewing shop with a huge range.

Willow Fabrics
www.willowfabrics.com
General suppliers of needlecrafting and embroidery materials.

Abakhan
www.abakhan.co.uk
Has several stores in the UK and an online shop, selling fabric and embroidery materials.

Royal School of Needlework
www.royal-needlework.org.uk
Tel: +44 (0)20 3166 6935
The RSN has an online shop, as well as information on classes and events.

Sweden

Borgs garner
www.borgsvavgarner.se
Sells mostly weaving materials and weaving threads.

Canvas
www.canvasshop.se
Online shop with a focus on embroidery.

Hemslöjden
www.hemslojden.org
Here you'll find links to arts and crafts shops throughout Sweden, including information on exhibitions, courses, etc.

Hobbylagret
www.hobbylagret.se
Dalvägen 10A, 169 56 Solna
Tel: +46 (0)8 282062
Sells weaving threads that also work well for embroidery.

Panduro Hobby
www.pandurohobby.se
Has outlets throughout Sweden and an online shop.

Svensk Hemslöjd
www.svenskhemslojd.com
Sveavägen 44, 111 34 Stockholm
Tel: +46 (0)8 232115
Sells embroidery threads, fabrics and other materials.

BIBLIOGRAPHY

In English

Fisher, Eivor. *Swedish Embroidery: Anchor Embroidery Book No.2 with Tracing Sheets*. London, Batsford, 1953.

Hauschild Lindberg, Jana. *Scandinavian Cross Stitch Designs*. London, Cassell Illustrated, 1996.

In Swedish

Bergström-Granquist, Emy. *Svenska mönsterboken del XIV: Svartstickfrån Leksands socken, Dalarna (The Swedish Pattern Book part XIV: Blackwork from the parish of Leksand, Dalarna)*. Stockholm 1942.

Brodén, Märta. *Delsbosöm: långsöm och tofssöm från Delsbo (Delsbo Embroidery: Long Stitch and Diamond Ray Stitch from Delsbo)*. LTs förlag, 1979.

Dandanell, Birgitta (ed). *Påsöm: folkligt broderi från Floda i Dalarna (På Embroidery: Traditional Embroidery from Floda in Dalarna)*. Dalarna Museum, 1992.

Eldvik, Beritoch Åsbrink, Brita. *Järvsösöm (Järvsö Embroidery)*. LTs förlag, 1979.

Hådell, Anna. *Svartstick (Blackwork)*. LTs förlag, 1980.

Johansson, Britta. *Hallandssöm (Halland Embroidery)*. LTs förlag, 1977.

Kristiansson, Maj-Britt. *Annundsjösöm (Anundsjö Stitch)*. LTs förlag, 1978.

Nordiska museum's collections.

INDEX

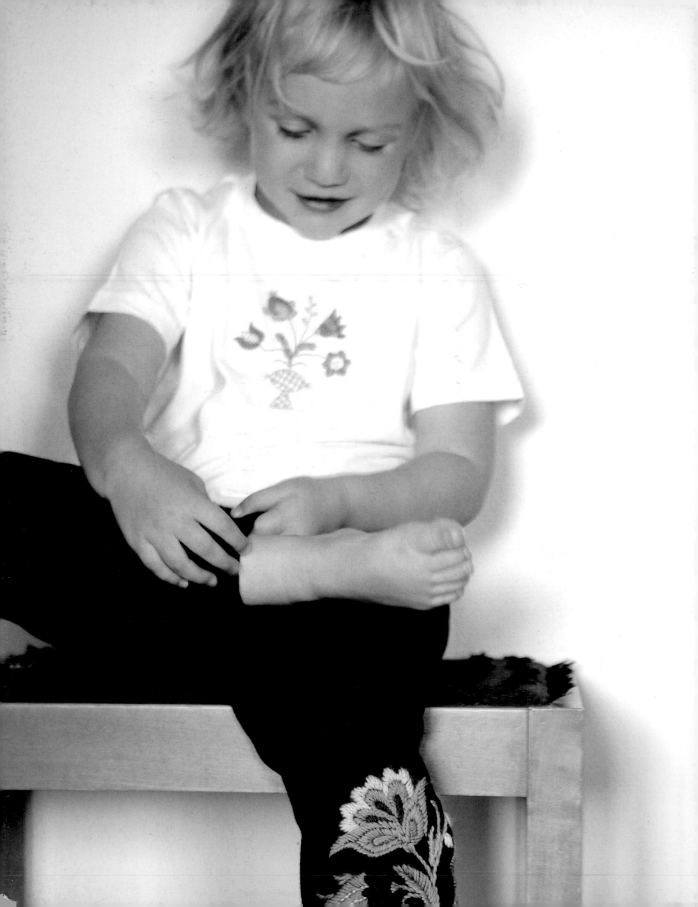